THE DIGITAL VIDEO MANUAL

THIS IS A CARLTON BOOK

Text and design copyright © 2002 Carlton
Books Limited

This edition published by
Carlton Books 2002
An imprint of the
Carlton Publishing Group
20 Mortimer Street
London
W1T 3JW

ISBN 1 84222 713 0 (HB)
 1 84222 515 4 (PB)

Executive Editor: Sarah Larter
Editorial: Chris Hawkes/David Ballheimer
Art Editor: Adam Wright
Design: Mike Spender
Picture Research: Stephen O'Kelly/Adrian
Bentley
Production: Janette Burgin

Printed in Dubai

THE DIGITAL VIDEO MANUAL

Robert Hull and Jamie Ewbank

An essential, up-to-date guide to the equipment, skills and techniques of digital videomaking

CARLTON
BOOKS

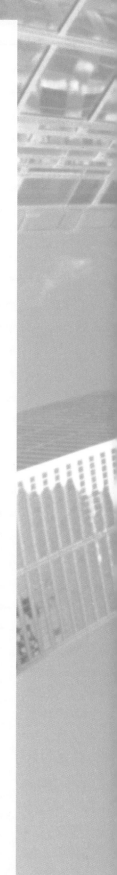

CONTENTS

6
Introduction

10
Scene 1:
Getting Started

36
Scene 2:
The Basics

52
Scene 3:
Skills

82
Scene 4:
Production Time

92
Scene 5:
What, Why, When

116
Scene 6:
Editing

136
Scene 7:
Distribution

154
Glossary and Contacts

159
Index

160
Acknowledgements

INTRODUCTION

Videomaking should always be an adventure, whether you are an experienced producer of your own movies or whether you just press the big red record button on special occasions. Every time you put the viewfinder to your eye, or gaze at the LCD screen on your camcorder, you are about to embark on a marvellous journey, which even with the best planning, will take you to places and put you in situations you might perhaps only have dreamed about.

We hope that by the end of this book you will be prepared to make even more journeys into the unknown with your camcorder, because seeing what you have recorded, in any capacity – whether it be at home on your TV, at a camcorder club screening, or even in competition with other videos – will give you an enormous buzz. Even experienced videomakers still get goosebumps when they see an amazing shot or a sequence they have created. It might have come by chance, it might have taken an age to plan and shoot, but, whatever it is, it is the outcome that matters. And you will soon discover, if you talk to anyone involved in film or videomaking, these are the moments they live for.

With the best will in the world, reading a book is not going to make you a videomaker. Both of us know this, but we also know, occasionally from harsh experience, that having the basics locked away somewhere in the little grey

cells can be a godsend. So, with that in mind, we set to the task of developing this book. Ultimately, we decided that the basics, quite frankly, were not going to be enough (and it would make this a pamphlet, not a book!). Instead, we thought it best to give you a taste of the whole shooting match, from the basics to the downright complicated – and yes, we thought it only right to include computer jargon as well!

The growth of digital technology, predominantly in the last seven years, has been enormous. I say the last seven years because that is how long it has been since Sony launched the first digital camcorder. Now, as we continue to edge into the twenty-first century, the range of equipment, and its capabilities, available to videomakers with all sorts of budgets is bewildering. Not only is it possible to pick up a high-quality DV camcorder for a reasonable price, but with the advent of computer-based, non-linear editing it is no exaggeration to state that professional-quality editing is possible from the PC in the living room or bedroom. The hours of faffing around with an edit VCR have now been replaced by the hours of faffing around with a PC or an Apple Mac!

It is also important to remember that even within the digital realm technology is changing. Camcorder manufacturers have already tried to vary the digital mix, with a MiniDisc camcorder from Sony and an MPEG camcorder being introduced by Hitachi. Neither of these really caught consumer imagination, but then, in 2001, Hitachi launched the first camcorder to record onto DVD. Digital tape is still likely to be with us for some time, but DVD points to one of the many routes forward. Heck, by the time you are reading this there might even be a camcorder that records onto its own internal hard disk rather than onto a tape!

Amid all this exciting new technology one point shines out like a beacon: no matter what camcorder you use, you are only as good as the shots you take, and so, with that, we suggest that you read on…

Robert Hull and Jamie Ewbank, 2002

1

Getting Started

Getting Started

A Brief History of Camcorders

Although digital technology is undoubtedly the future of video-making, it is worth knowing a little about the camcorder's past. According to myth and legend – well actually according to Sony – the first consumer camcorder was launched way back in 1980. However it wasn't until 1985 that a real battleground emerged with Sony launching the 8mm recording format, while JVC introduced its compact version of the VHS format, in VHS-C. Consumers now had access to machines which were both a camera and a recorder, hence **cam**era and re**corder**, whereas previously they had been seen wandering around with two separate boxes, one for taking the images, the other for recording them.

Early Days

These first machines used analogue recording methods and as such the quality of the pictures was somewhat below that seen on a TV screen. The United Kingdom, Australia, New Zealand and parts of Western Europe use the **PAL** (Phase Alternating Line) TV colour standard, which builds a television picture through 625 horizontal lines. France uses the **Secam** standard (again 625 lines), while the USA and Japan use the **NTSC** standard (525 horizontal lines). While not all these lines are used for creating the images – some are simply used for providing information – the fact that both the 8mm and VHS-C formats were capable of a line resolution of around 240 lines, gives you some indication as to the picture quality on offer. Alternatively you could always just check out a home video bloopers show and when the really ropey looking stuff comes on ... that'll be analogue camcorders!

Television would obviously be more interesting if you were producing the programmes.

The concept of video tape recording for your home takes on a thrilling new dimension when you add a colour video camera to your system and start producing your own programmes.

Especially when the camera is astonishingly portable, easy-to-use, and equipped with such 'Hollywood-type' features as a super-zoom 6X lens and fully rotatable viewfinder.

That is how we've designed the GC-4100 portable colour video camera, using all the video technology we've accumulated since we developed the VHS system itself.

And if you add the companion HR-4100 portable colour video cassette recorder, and a separate television tuner, you can have all the versatility of a home video system you could ever want. It could really change the way you watch television.

We know. We're JVC, the innovative audio/video electronics company with 52 years of experience.

You can count on us to make your life more interesting and more rewarding.

Visit your nearest authorized JVC dealer today, and discover how, with our portable colour VTR equipment, we can also make your television more interesting—simply by putting you in the picture.

VHS

JVC

ABOVE, LEFT TO RIGHT:
Examples of Sony, Panasonic and JVC's popular analogue video cameras.

However, despite the somewhat duff picture quality, camcorders became a desirable product throughout the late 1980s and early 1990s as household after household fell for the novelty value of seeing yourself and your friends on video. Camcorder sales peaked in the early 1990s due to the success of manufacturers providing smaller camcorders with increased features, at more affordable prices. It has also helped that some of the most popular television programmes worldwide (such as Britain's *You've Been Framed* and *America's Funniest Home Videos*) are devoted to home movies.

A NEW BREED

Every dog has its day, however, and though still popular in the mid-1990s, the camcorder's moment in the spotlight was ebbing away. The arrival of new technology: home cinema, DVD, mobile phones, gaming technology and the Internet, meant consumers' attention was divided even further, and consequently video-making lost out.

Fortunately, the major electronics manufacturers had a trick up their sleeves that would make videomaking vital again. In 1995 Sony produced the world's first digital camcorder, the DCR-VX1000. This large, not especially attractive, camcorder recorded onto small digital cassettes using the Mini DV (Digital Video) format. Images were crisp, clear and full of detail, the camcorder had several important manual controls and high-quality digital sound. It was also possible to add an external microphone.

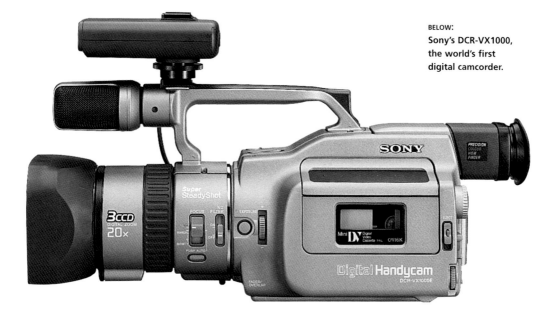

BELOW:
Sony's DCR-VX1000, the world's first digital camcorder.

Although hardly aimed at the general or casual user, it provided a tantalizing taster of what was to come. The term "Broadcast Quality", often the barometer of whether footage was good enough to be shown on TV or the cinema screen, was about to take a battering. Context became the important issue.

Quick to spot the benefits of the VX1000 the BBC soon bought a plentiful supply. To its cameramen and women, used to lugging around larger format film and video cameras, the VX1000 was not a large camera. In fact it allowed them to take camcorders into previously undiscovered areas. The era of the fly-on-the-wall, "docusoap" and reality TV show was upon us.

BIGGER IS NOT ALWAYS BETTER

Following the launch of the VX1000, JVC, Panasonic and Canon soon followed with their own DV models and a contest of miniaturization began. Every quarter, as launches were made,

there would be a new claim for the world's smallest camcorder. The range of designs on the market became bewildering: you could have an upright or "book"-style DV camcorder, a rectangular-styled palmcorder, a camcorder that looked like an SLR camera, or, if simplicity was your bag, a square camcorder.

As the list of digital camcorders grew towards the end of the 1990s, so did the amount of features available to the consumer. Digital effects and zooms increased, video lights were added, batteries were made smaller, LCD screens were made bigger. Soon it became possible to take digital snaps with your camcorder and decide whether you wanted to store them on tape or on a supplied storage card. You could, therefore, have the best of both worlds – a way of taking both moving and still images. Yet, despite this rush, some seasoned videomakers felt the new camcorders were selling them short.

In the early days, camcorder controls were large and easy to operate, and control over focus, exposure, zoom, white balance and shutter speeds was manual. With the increasing miniaturization, these features were being sacrificed for functions that made it easier for a salesmen to "sell" the camcorder. A camcorder with a 500x digital zoom is virtually unusable, as the camcorder needs to be completely steady or either the shot will be lost, or the amount of **pixellation** (distortion) of the image will be so high as to make the image unintelligible.

SOMETHING FOR EVERYONE

To this end the camcorder market now divides into three distinct sections: budget, entry-level and enthusiast. There are consumer DV camcorders available for both under £/US$ 500 and over £/US$ 3,000, and at many price points in

between. What is more, the level of design is now sophisticated enough to be able to distinguish between the different needs of the variety of customers. Enthusiast camcorders have more manual control over sound and video, have less digital and picture effects – in general, less gimmicks. They tend to be slightly larger and more complicated to use than their counterparts in the budget and entry-level sectors. Here you will find a real dogfight for your money. Feature counts will be high, but corners might have been cut in terms of build quality, as well as image and sound quality.

However, as video-making continues its dash into the twenty-first century, the range of products on offer to consumers has never been greater, nor has the performance rating of camcorders been higher. With digital videomaking now more affordable, there is now virtually no limit on what can be achieved, whether it be from the comfort of your living room, or as part of a semi-professional set-up. Digital videomaking now dovetails beautifully with the power of desktop video. Computers and camcorders can now meet and, within a few hours, videos can be stitched together with basic cuts and transitions, or, for the more ambitious, with previously very expensive special effects.

CHANGING THE OLD ORDER

Even film-makers have had to take note of the power of digital video, as traditionalists used to cutting on film now make way for the power of the pixel and the PC. Hollywood is increasingly utilizing the flexibility and time-saving aspects of digital video. Initially, this was in the post-production houses famous for adding the "special" bit to film effects, but now this can even include shooting feature films on digital video cameras.

ABOVE:
The Panasonic NV-MX300, a definite enthusiast's camcorder.

Camcorders can now record onto DVD disks, or in the case of Sony's MICROMV format, using MPEG2 compression, onto cassettes smaller than a book of matches.

It is easy to be blinded by the speed of technology, but through this tremendously accelerated journey it is worth bearing in mind that, ultimately, though technology will help you make your ideas a reality, you have got to be able to point the camera in the right direction and know which button to press before you can do it. You can't put a price on basic videomaking know-how!

From Analogue to Digital – A Camcorder Timeline

1980 Sony introduces first consumer camcorder in Japan.

1985 Sony launches 8mm recording format. JVC counters with the introduction of the VHS-C format, a compact version of its VHS technology.

1988 JVC ups the ante with arrival of Super VHS (S-VHS) format.

1989 Touché! Sony reacts with the Hi8 format, offering video-makers increased picture quality, and eventually stereo sound.

1995 First Mini DV (Digital Video) camcorder arrives in the UK. It is the Sony DCR-VX1000, and though it costs significantly more than analogue consumer camcorders it is soon adopted by TV companies, production companies and semi-professional videomakers due to its exceptional picture quality.

1996 JVC and Panasonic launch DV camcorders into the UK market. JVC's GR-DV1 is the first example of a palmcorder, so called because it is so small it fits neatly into the user's hand.

1997 An omen of things to come? DVD players having been on sale in Japan for a year, are now available in the USA. Hitachi tries to change the camcorder market, unveiling its MP-EG1A camcorder towards the end of the year. This is the first tapeless camcorder, using MPEG compression to record digital images onto an internal hard disk. Image quality is unimpressive and price seems too high for consumers – it flops.

RIGHT:
Sony's Hi8 Handycam.

1999 Sony introduces the Digital8 format. These new camcorders allow the user to record digital images onto analogue 8mm/Hi8 tape. Backwards compatibility means you can replay your existing 8mm/Hi8 tapes in the new machines!

2000 Hitachi and Sony announce plans for new camcorders. Hitachi's plans include a DVD camcorder, while Sony unleashes a MiniDisc camcorder.

2001 Hitachi's DZ-MV100 DVD RAM camcorder goes on sale for around £1,800. Sony hits back, however, with a brand-new format MICROMV. Recording onto tapes smaller than Mini DV cassettes and using MPEG2 compression.

Why Choose Digital?

Inevitably with the rise of digital technology the cost of analogue equipment has fallen. It is now possible to buy a basic "point-and-shoot" analogue model for under £/US$300. So why, you might ask, do you need to buy digital, when

you can save money on analogue equipment? It is an intriguing question because as any experienced videomaker will tell you, making movies – even amateur ones – can be an expensive business. Fortunately for us there are many answers to this conundrum.

Chiefly, digital image and audio quality is superior to that from analogue machines. Even digital camcorders at the budget end of the market will provide far better picture quality than that seen from 8mm, VHS-C, S-VHS-C or Hi8 formats. In terms of horizontal line resolution, a basic DV camcorder will resolve around 400 lines, colours will be reproduced more accurately than on analogue formats and there will be a sharpness and detail to the images that is unavailable on other formats.

SOUND

Audio, on the other hand, has always been something of a troubling matter for camcorders. The microphones included on all but the most expensive (and high end) camcorders are generally one of the cheapest components used. Consequently sound quality does not always match the clarity of the images recorded. Even with digital technology there is a disparity between the quality of the images and audio. As a rule, most DV camcorders use **PCM** (Pulse Code Modulation) stereo sound. This is audio that has been digitized. It is available in two settings 16-bit (48kHz, two channels) and 12-bit (32kHz, two from four channels). The first setting provides the highest-quality sound recording, often claimed to be slightly better than CD quality, though in reality slightly worse! The second setting does not produce as dynamic or fully rounded sound, but as it only records onto two, out of four, channels, a further two channels are left open for adding narration or soundtrack dialogue/music at a later date.

In reality, the audio performance of DV camcorders is acceptable rather than inspiring, but it is still an improvement on the recording methods of analogue camcorders, if only because of the flexibility it offers.

NON-LINEAR EDITING

Aside from the improved performance criteria, digital camcorders have also helped support the growth in computer-based editing. This is commonly known as non-linear editing (NLE), as footage can be chopped, changed and moved around at will, rather than being edited in a linear fashion. Computer hardware and software is necessary for this, and footage is often displayed on the computer monitor in a form known as a "timeline". This shows video and audio information which can then be re-ordered and have titles, transitions and effects added to it.

All digital camcorders incorporate a **Firewire** socket among their terminals. This is a connection protocol developed by Sony, which allows for data communication at very high transfer rates. It can often be referred to by its technical name, IEEE-1394, but is more commonly known as Firewire.

A camcorder can be connected to either a PC or a Mac computer through a Firewire cable. The Firewire socket on a camcorder is a four-pin affair while on most computers the socket is six-pin. Therefore, the cable that connects the camcorder and the computer has one six-pin and one four-pin connection. Using the cable it is then possible to transmit the data from the DV tape in the camcorder onto the hard drive of the computer. From here, provided you have the right hardware and software, you can run amok with your footage, adding bits, trimming clips,

changing the running order – as well as at a later date creating your own Video CDs, Internet movies and ultimately DVDs.

FACING THE FUTURE

And what about the future? Well, if picture, sound quality and computer-based editing weren't enough to convince you, then try the fact that within the next couple of years you might not be able to buy a new analogue camcorder at all!

Sony has introduced its MICROMV format, and Hitachi has launched several DVD camcorders, these are still just forays into new ways of recording images. Mini DV, due to its lightweight camcorders, affordable tapes and computer compatibility, is almost certain to remain the most popular and convenient mass market way of creating and distributing video.

Sony has already ceased production of its 8mm camcorders, and while its Hi8 still remains popular, who knows how long it has left, considering the success of Sony's backwards compatible Digital8 format. JVC, the architects of VHS and once committed to the format, have also confessed to seeing a time without analogue camcorders, and have been one of the busiest manufacturers in addressing the budget end of the digital camcorder market.

Yet, by its very nature, the electronics industry is subject to fast-paced change. So what of the future of digital video. Although

Choose digital because of:
• Picture quality.
• PCM stereo sound.
• Opportunity for non-linear (computer) editing.
• Compatibility with other technologies: digital cameras, DVD, Internet and email applications.
• Death of analogue camcorders.
• Cost.

Buying the Right Digital Camcorder

The most common question asked of anyone "in the know" about camcorders is usually, which one should I buy? It is not that it is an impossible question to answer, it is just that once consumers realize the potential number of answers, their buying decision seems to become more complicated.

Cost is the most important consideration when buying a camcorder. The range of camcorders on offer is huge, and because of canny marketing there is a model that will appeal to everyone, but consumers need to know how much they can spend, in order that they can be advised properly. As we mentioned previously, the camcorder market is divided into three sections: budget, entry-level and enthusiast. Obviously prices change rapidly and there is no

way of keeping track of them during the lifetime of a book, so you should keep your eyes trained on the videomaking press and price comparison sites on the Internet. However, as a rough guide, the three sections break down this way.

Budget: prices generally sub £/$US500 to around £/$US800.
Entry-level: prices generally £/$US800 to around £/$US1,200.
Enthusiast: price generally upwards of £/$US1,200.

What you get for your money is vastly different. Enthusiast camcorders are usually larger than their counterparts, have a wide selection of manual controls, have advanced level of socketry including Firewire in and out, analogue inputs and outputs, and will require an invest-

ABOVE:
One of the most popular uses for camcorders is to create lasting memories of idyllic holidays.

RIGHT:
Camcorders are getting
smaller and far easier to
take with you ...
anywhere.

Mini DV, Digital8, DVD-RAM and MICROMV. The first two are by far the most popular and prevalent and unless your needs are very specific you should look here first.

Mini DV

The most popular DV format. Tapes are smaller than a box of matches, affordable and are capable of producing high quality images and audio. Tape lengths vary but are available in 30, 60- and 90-minute options. There are in excess of 80 camcorders on offer using this format, and they are noted for their compact, lightweight design.

ment of your time to learn how to use them effectively. Camcorders in the other two sections will mix and match features and functions, with an increasing number of digital and picture effects becoming available, while manual features – the favourites of any experienced videomaker as it allows them to control how the footage is recorded – will take a back seat. Budget camcorders are designed to be very easy to use, and to provide reasonable results "for the money", but they won't have the flexibility or control of more expensive models.

Once you decide which user you want to be your choice becomes easier. If you want an easy-to-use camcorder for recording the odd family event, there is no point shelling out £/$US1,500 on a model with all the features a semi-pro would want. And likewise, if you want to edit videos on your home computer, while also digitizing existing analogue footage, you will be left wanting if you are tempted by the sub-£/$US500 price tag of a budget DV model.

Digital Formats

In order to buy the right camcorder you should first decide on the right format. There are currently four consumer digital video formats:

Digital8

Around ten models of Digital8 camcorder are available. Predominantly from Sony, the inventors of the format, although Hitachi also have a model available.

Camcorders are similar in design to Hi8 models in that they are large, fairly bulky and decidedly heavy in comparison to their pure DV counterparts. The benefit of the format is that the camcorders use 8mm and Hi8 tapes but record images of a digital quality, while they can also play back your existing 8mm and Hi8 tapes.

DVD-RAM

Only Hitachi has so far entered this market in the UK – though Panasonic has sold a DVD camcorder in Japan. The camcorder records digital images, sound and stills, using MPEG2 compression, onto an 8cm rewritable DVD disk, housed in a caddy that fits into the left-hand side of the camcorder. On the first UK model, the DZ-MV100, the disk had 1.4 gigabyte (GB) capacity on each side and provided a maximum recording time of 60 minutes (30 minutes per side). Image quality was not quite up to DV standard, and you could not play the DVD in a conventional DVD player. New models in 2002 have addressed some of the initial problems, but Hitachi stands alone in promoting this format.

MICROMV

This format was introduced by Sony in the summer of 2001. Tapes are smaller than Mini DV and images are recorded using MPEG2 compression. Picture quality is around the same as Mini DV, but there are problems on playback, with a slight pause being apparent at the end of each recorded segment.

Two models are available at time of publication: the DCR-IP7 and DCR-IP5. The former boasts Bluetooth wireless technology, which allows the camcorder to surf the Internet, and both send and receive emails.

Once you have selected your DV format, it is time to move on to the main features which will try and separate you from your hard earned cash. Some of these features are about as much use as a chocolate fireguard, but there are plenty that will help you distinguish just what sort of camcorder user you are.

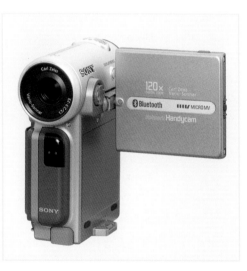

LEFT:
The next step. Is DVD-RAM or MICROMV the future of digital video?

FIREWIRE (DV-IN-AND-OUT)

Firewire sockets allow the DV signal to transfer between suitably equipped devices, the most common cases being a digital camcorder and a computer. All digital camcorders have a Firewire socket, but only a small percentage of them allow the digital signal to be sent and received. Hence you will see plenty of camcorders referred to as DV-out, but few as DV-in-and-out.

DV-out only means you can transfer your DV footage to the computer for editing, but once there you cannot transfer it back to a blank DV tape waiting in your camcorder – and so complete a fully digital video.

The reason for the lack of DV-in-and-out camcorders has long been a moot point. Manufacturers claim that in the eyes of Customs and Excise a DV camcorder capable of recording a signal from another source is also a VCR (Video Cassette Recorder) and liable to more duty. Therefore, the price of a DV-in-and-out model is usually more than that of a DV-out only. In their wisdom, camcorder manufacturers took it upon themselves to claim that consumers would not be willing to pay the extra for DV-in-and-out, even when, as we have pointed out, it is necessary to get the full benefit from digital video and computer editing.

What is frustrating for UK users is that all digital camcorders can actually send and receive via Firewire, but because of the Customs problem, camcorders coming to the UK are deliberately neutered to disable their DV-inputs. Camcorder manufacturers have increased the number of DV-in-and-out models, usually by including at least one of them in a new range, and there is also a burgeoning market in products called Widgets, as well as software hacks, that allow consumers to reactivate the DV-in socketry on their camcorders – at the cost of invalidating the camcorder's warranty!

If non-linear editing figures highly in your criteria for buying a digital camcorder, make sure you consider the DV-in-and-out question.

ABOVE:
Socketry is an important factor in selecting a camcorder.

ANALOGUE INPUTS

Generally found on enthusiast models, analogue inputs allow an analogue source i.e. a camcorder or VCR to be connected to the digital camcorder. It is then possible to record the analogue material onto digital tape. For users moving from analogue to digital, this is a useful way of archiving material in a digital format, or should you wish to edit on a computer you can now incorporate analogue footage.

MANUAL CONTROLS

A must if you want to take videomaking seriously and take control of your productions. All but the most basic DV camcorders will allow you to take manual control over focus, but you will have to check specifications carefully if you want manual exposure, shutter speeds, iris or white balance controls.

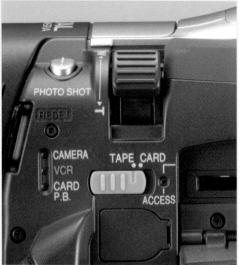

On enthusiast models the manual controls tend to involve larger buttons, and potentially a manual focus ring around the lens, rather than a small thumbwheel on the side or back of the camcorder.

ZOOM

It's an easy adage to remember: optical zoom = good, digital zoom = bad!

One of the easiest videomaking mistakes to make is to overuse the zoom. Check out your favourite films and TV shows and see how little the professionals use it, and when they do, why it is often purely stylistic. If you want to see something closer, move closer to it!

Optical zooms can run up to 25x magnification, a perfectly adequate number, which creates no picture degradation. Digital zooms can run up to 700x magnification and increase pixellation (picture noise) on your images, while also causing you to use a tripod in order to keep the camcorder steady enough to see anything. If you are still interested in digital zoom perhaps it is worth asking yourself: is the best way to record your favourite image by standing ten miles away from it?

IMAGE STABILIZATION

Two image stabilization systems have grown up over the years. Optical and Digital (Electronic). Video purists have often hankered solely after the optical system, as it does not electronically alter the image in order to keep it steady, and therefore your footage will not suffer from any picture noise. However, optical systems increase the size of a camcorder and in the age of miniaturization, the digital system has become more prevalent. This system, sensing camcorder shake, electronically enlarges a 70 per cent portion of your image and stores this to tape instead. The camcorder then compares each image with the last and moves this enlarged

LEFT:
An optical zoom in of up to 25x magnification is more than adequate for most video-making.

portion up and down in order to keep the key elements in the same position.

Initially digital stabilization was prone to increasing picture noise, but recent systems have shown a marked improvement.

However, the best form of image stabilization known to videomakers is still a tripod!

SOCKETS

Small things, but things that are often overlooked, the inclusion of key sockets on your camcorder can often make the difference between a polished production and a gremlin-encrusted nightmare. The two most important, after DV-in-and-out, are an external microphone socket and a headphone jack. The first allows you to bypass the basic microphone on your camcorder and invest in a far more subtle and sophisticated version, which is likely to give you a fuller, more directional sound.

The headphone jack is important for enabling you to hear what your camcorder is recording in the audio department. This is useful for picking up fluffed lines, over-flying aircraft, squeaks, buzzes and other noises you might not necessarily want on your footage.

VIEWFINDER/LCD

Digital camcorders invariably feature both optical viewfinders and LCD screens. They can both be used for framing images, but the LCD screen does place extra draw on the camcorder battery. LCD screens range in size from around 1.8 inches to 3.5 inches and are always colour. They are

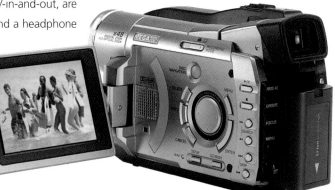

best used for reviewing footage, and as most camcorders have built-in speakers, you can watch and listen to footage taken only seconds ago. The larger the LCD screen the more money you will pay, but be warned: LCD screens hate bright sunlight, and can often be rendered useless by it.

Viewfinders are now predominantly colour, though traditionalists have always preferred black-and-white viewfinders for the exposure and contrast "hints" they give. Sadly, even high-end, enthusiast camcorders now use colour viewfinders, though you can find accessories for some of these camcorders, such as Canon's DM-XL-1 or DM-XL1S, which include black-and-white viewfinders.

RIGHT
Sock-et to 'em: Analogue, Firewire and PC connections.

Again miniaturization has caused view-finders to be reduced in size, so, if only from a comfort point of view, be sure to check the eyepiece you might be gazing down for hours on end is comfortable.

AUDIO

If you want flexibility in the audio department, look out for camcorders which feature audio dub – most camcorders utilizing 16-bit and 12-bit PCM stereo sound feature it, but not all. Audio mix is also another useful function, as it allows you to balance the level of sound coming from the different stereo channels.

DIGITAL STILLS STORAGE

Do you want your camcorder to be your camera as well? If so, virtually every camcorder from budget models to enthusiast camcorders can oblige. Previously restricted to storing snaps to Mini DV tape, digital camcorders now record high-quality stills to multimedia cards. Images can be printed out via computer or sent as email attachments. The number of still images that can be stored depends on the MegaByte (MB) capacity of the storage card. Image quality has improved to a point where some enthusiast camcorders are capable of stills approaching the quality of 35mm film.

CHOOSING THE RIGHT COMPUTER

One of the reasons why DV has become so popular, aside from its high quality, is the ease with which it can be imported and altered using a computer. Computer programs are a digital environment and, as such, are happy to work with digital video, exploiting the massive range of software and hardware available and allowing you to edit your videos, add special effects, create video emails, compress films for broadcast over the Internet and even author your own DVD videos and Video CDs. All of this is done without having to alter or compress the information on tape, meaning that you will suffer no loss of quality in your footage.

You can buy what are known as "one-box" systems for video editing that contain all the components and software you need to edit video, but these can be expensive and, unlike a computer, can only be used for video editing. Additionally, should you not like the particular software on a one-box system, or find that you require features it does not possess, then you have wasted a lot of money. Computers, on the other hand, can be turned to many more uses and can be easily upgraded, which is why we

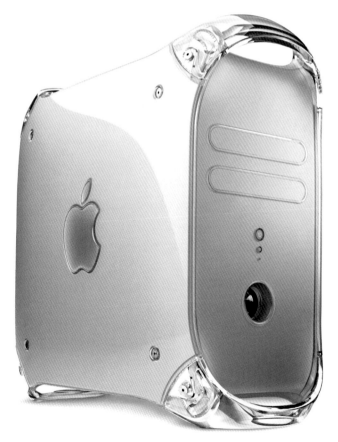

BELOW:
The Apple Mac has a dedicated following among computer users.

would always recommend a trip to the PC store over a one-box editor.

That is not to say that you have to turn your front room into Industrial Light and Magic simply to enjoy using your camcorder, but it is worth bearing in mind that the DV format opens up such a wealth of possibilities that it would be wrong not to consider what benefits a good computer with well-chosen software can bring to your videomaking.

Your camcorder will have a DV-out socket at the very least, and hopefully a two-way DV in-out socket if you were paying attention during the last section. It should also have come with a DV cable for transferring the information via the camcorder's DV socket to one located on your computer.

DV cable goes under a variety of different names – Apple, who own the copyright, call it Firewire, Sony refer to it as iLink, most of the PC world knows it by the rather long-winded IEEE1394. In essence it is a cable and socket system that draws its power from the devices it is attached to and allows the high-speed transfer of information between your camcorder and computer.

The type of computer you'll choose to use for DV editing will depend on your personal tastes and the generosity of your bank manager (put him on your Christmas card list now.)

The first question to think about is whether you chose Apple Mac or PC. PC essentially means Personal Computer and, as such, technically refers to Macs as well. Over the years, however, PC has come to be used as a generic term for a computer with an Intel or AMD processor that runs Microsoft's Windows operating system. Macs, on the other hand, use processors known as G3s or G4s and an operating system known as the Mac OS.

These operating systems are likely to be the point that demand the most consideration when choosing a computer. The Windows system, in one of its many forms (95, 98, 98SE, NT, Millennium Edition, 2000 or the latest XP) is used on around 90 per cent of the world's computers

LEFT:
An iMac running OS X provides stability, built-in sockets and basic editing software.

and is likely to be instantly familiar to anyone who has so much as glanced at a computer.

Whereas Windows can be found on computers made by a massive variety of manufacturers, the Mac OS is found exclusively on machines manufactured by Apple Macintosh. Both systems have their respective strong and weak points.

The Mac OS is stable, that is it does not crash very often, intuitive, versatile and stylish. Windows, on the other hand, is less stable, less stylish and, for videomakers, quite restrictive. On the other hand, it does have the massive advantage of ubiquity – Windows machines are everywhere, which makes them the priority market for software developers and means that there is a much wider range of software and accessories available for Windows machines. Additionally, the familiarity of the Windows operating system makes it easy for beginners to learn and communication between different computers is rarely a problem as the likelihood is that they will both be using the same system.

Mac and PC users have a tendency to be clannishly devoted to their machines and you will be able to tell them apart by looking at their eyes – Mac users will have a melancholy look brought on by staring wistfully at adverts for wondrous software that isn't designed to work on their machine, whereas Windows users will have bloodshot eyes, having spent several nights awake trying to rescue the huge amounts of data lost when their computer last crashed.

Most users will invariably choose the operating system that they are most familiar with – be it the one from work, college, or an existing home PC. There is absolutely nothing wrong with sticking with what you know, but, just for the record, we would recommend that you have a look at both Macs and PCs and try and work out which system suits you best, bearing in mind that a computer is a big investment and that you will probably want to use it for more than just video-related work.

One thing to think about is that Apple Macs (the iMac, iBook, Powerbook and G4) all feature firewire sockets and iMovie2, a very basic piece of video editing software. Many PCs, on the other hand, will need to you to install a capture card (a device with a DV socket) and your choice of editing software separately. This is not necessarily a bad thing because many capture cards feature onboard video-specific processors which will help lighten the load on your computer's processor. As manufacturers become more aware of the needs of videomakers, more and more PCs are being made with the relevant sockets and software built in.

Another point to bear in mind is that older versions of the Windows operating system, such as 95, 98 and 98 SE impose a limit of 4GB on the size of information files. This sounds like a lot, but in truth it is only about 18 minutes of video, meaning that projects longer than that will need to be split into several smaller files.

Having decided whether to go for a Mac or PC you then need to look at the hardware itself –

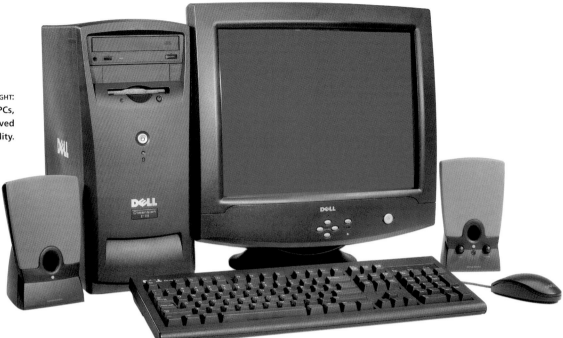

most importantly the processor and the memory.

The processor is the brain of your computer, the part that does all the "thinking". When you give your computer a command it is the processor that works out what that command means and what effect it will have upon the work you are doing. A fast processor is essential, as video editing will often require your processor to execute a staggering number of commands and you really don't want to be waiting around for your processor to carry them out.

A common method of assessing the power or speed of a processor is by looking at its clock speed – the number quoted in MegaHertz. As a very rough guide, a 700MHz processor can execute about 700,000,000 commands in a second. However, the actual design of the processor (essentially a microchip with millions of tiny transistors and a basic understanding of the words yes and no) can have a massive effect on its performance. Hence a Pentium 4 processor is likely to be more efficient than a Pentium 3, even if they have the same clock speed, whilst a 733MHz G4 processor in a Mac is considered by Mac users to be the equivalent performer to a 1.7 GigaHertz processor on a PC!

While you won't necessarily require a top-of-the-line, fastest-on-the-market processor for video editing, a good processor will make a lot of difference, and, considering that it is much harder to upgrade your processor than it is to increase RAM or HDD capacity, it is worth looking for the fastest (and hence, most future proof) processor your budget will run to. Think Pentium 4, G4 and AMD Athlon/Athlon XP, and look for a nice high clockspeed, then phone your bank manager and ask him if he liked his christmas card.

Memory comes in two forms – the information stored on your hard disk and the information stored in the Random Access Memory (RAM). RAM holds the information

your computer is working with at any given time and is used by the processor when executing commands. Anything stored in RAM will disappear when the computer is turned off, whereas the Hard Disk is used to store the information permanently. A common (and accurate) cliché is that the Hard Disk is the equivalent of long-term memory, whilst RAM is the short-term memory that your computer is working with.

When you install a piece of software it "lives" on your hard disk, when you start it up and begin working with it, however, your processor will transfer the relevant information needed to run the software to the RAM, which is composed of

a series of chips mounted on a printed circuit board known as a DIMM. RAM operates much faster, but at much lower capacity, than the large spinning Hard Disk, and can feed information to the processor at higher speed.

A common mistake among novice computer users is to confuse the two types of memory, meaning that an inexperienced user, when told that his machine does not have enough memory to execute a command, will attempt to "free

up" some memory by pointlessly removing items from the hard disk, rather than simply buying and fitting more RAM into the slots helpfully provided on most computers. (RAM is ludicrously cheap and fairly easy to fit – upgrading your memory won't necessitate another call to the bank manager.)

As a rough guide, when planning to use a computer to edit video, do not look at anything with less than 256MB RAM and possibly consider 512MB – you probably won't need that much, but it is better to have memory that you don't use than it is to sit there clicking through endless dialogue boxes laughing at you for trying to add half a dozen special effects to a clip when your computer is suffering from digital Alzheimers.

Similarly, when looking at the hard disk drive's capacity, keep in mind that video files are big, and will usually be measured in GigaBytes (Bits being the smallest piece of computer information, eight bits to a Byte, 1024 Bytes to a KiloByte, 1024 KB to a MegaByte, 1024 MB to a GigaByte).

Even if you plan to limit yourself to only having a single video project on your computer at a time, you will still find that it takes up a lot of room – a half-hour finished project will take up over 8GB and that project itself will probably have been put together from a couple of hours worth of footage. Separate, external hard drives can be plugged into your computer to provide additional storage space, but that is an extra expense. It is better to look for a machine with a high capacity drive to start with – start at 20GB and go higher if you can.

LEFT:
Many older PCs will require you to fit a DV capture card. Don't panic – it is easy to do.

One last point to remember is not to take software manufacturers at face value – not that we would suggest that they would ever lie to you, but the truth can be open to interpretation. When looking at the side of a software box and reading the minimum system requirements, keep in mind that they want your money – if it says it will run on Windows 98 with a Pentium II processor and 128MB RAM then it will, but probably in a slow and unreliable fashion. Do not choose a computer based on the minimum requirements of the software you plan to run on it, and do not believe that a piece of software will definitely work well on your system when it may, in fact, only just limp along.

This all may sound like a daunting shopping expedition, but in truth you can look at the basic specs of any Mac or PC and, as long as you bear in mind the information above, have a pretty good idea of whether it will do what you want it to. Do not be put off by the expense either – your computer will be useful for more than just video editing.

Buying the Right Accessories

To capture the best images and audio you need more than just a camcorder, you need accessories! Chosen and used wisely these can help to add professional touches to your videos and they also help to make you a more proficient and organized producer. The miniaturization of technology attendant to digital video has seen many videomakers discard what are otherwise essential tools. Never assume that the tiny dimensions of your camcorder, and the quality of digital video don't need a helping hand from time to time. There's a wide array of accessories on offer, and though you don't necessarily need

to possess all of them, it will be beneficial to have a selection.

CAMCORDER SUPPORTS

A tripod is the most important accessory you can have. It will enable you to shoot from a wide variety of angles and heights, and from a stable platform, and for these reasons it is essential. Prices range from very cheap to staggeringly expensive. Tripods aimed at semi-professional and professional users are incredibly stable, but weigh a prodigious amount. Depending on the cost of the tripod these set-ups can be sold separately, so you purchase a video head and a set of tripod legs that you then combine. Remember in professional productions there's always someone to cart the gear around, whereas in your productions it could well just be you!

If you are going to be shooting regularly you

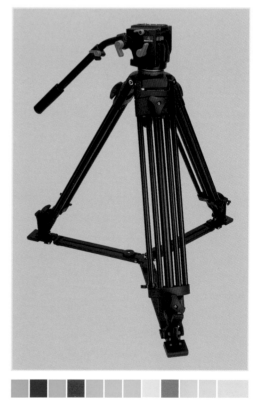

RIGHT:
Get yourself some support! A tripod is a videomaking necessity.

will need a durable tripod that offers aluminium and/or graphite construction, a spirit level – either on the tripod head or legs – to ensure your shots are even, and a quick-release platform. This allows you to slide the camcorder on and off the tripod without having to unscrew the bolt that attaches the camcorder to the quick release platform. This is most beneficial when you are moving around a location and setting up new shots.

There are other forms of camcorder support,

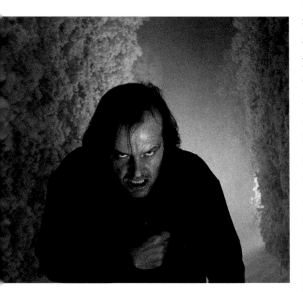

such as a monopod, which is a single leg version of the tripod. Naturally it does not provide as much stability but is useful in locations where space is at a premium. It is also lighter, and invariably cheaper than a tripod. A chest pod can also be used to brace the camcorder against you for stability. Finally it's also worth mentioning Steadicam systems.

Created during the making of Stanley Kubrick's *The Shining*, Steadicam is a support that has no contact with the floor. Instead it uses a system of weights and counterweights below the camcorder to keep it level. It allows

the camcorder operator to move freely with the camcorder and shoot smooth footage, as well as allowing you to get closer to the action. Professional systems are prohibitively expensive for most amateur productions but there are cut-down, budget systems available which offer many of the same benefits.

CAMCORDER PROTECTORS

Received wisdom says you don't get your camcorder wet – as it will not work! However, there are occasions where you might be shooting footage around, near or even in water, and, yep, it can also start raining. So, what can you do? Inexpensive rainjackets are available to cover the camcorder in light rain, and more substantial protection is on offer from some of the accessory companies in the back of this book. Underwater housing for many DV camcorders is also available. A number of manufacturers can tailor make a housing for you, but both camcorder makers and accessory firms supply one-size-fits-all options.

LEFT:
The Shining, directed by Stanley Kubrick, used the innovative Steadicam system.

BELOW:
Cover star. Your camcorder is precious so keep it protected from the elements.

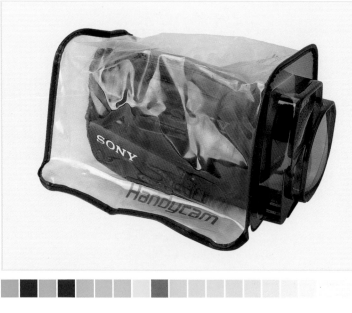

FILTERS

Material placed in front of the camcorder lens to modify the light entering it. Used for creating a special effects. The range of filters on offer is incredibly diverse and include filters that merely protect the camcorder lens itself (Skylight filter) to graduated filters that can gradually change colour from clear at the bottom to a colour at the top.

FILTERS

Other filters include:

Neutral Density: for reducing the threat of underexposure in bright conditions, and for reducing depth of field.

Colour Correcting: change the overall hue of the whole frame.

Polarizing: for eliminating reflections, such as those from mirrors or water. Your camcorder lens has a filter diameter (i.e. 43mm, 37mm) and this helps you select the right size to fit your model. However, it's also possible to buy a Matte box, which clips around your camcorder's lens and allows you to slot in any type of filter.

LENS CONVERTERS

Very useful for grabbing detailed shots, with a difference. Lens converters fall into two categories, teleconverters and wideangle converters. Teleconverters increase the focal length of your camcorder's lens, while wideangle converters do the opposite. Take, for example Sony's DCR-PC9 digital camcorder, with its 3.3–33mm focal length. This gives it a 10x optical zoom. Adding a 2x teleconverter lens would increase its maximum focal length to 66mm – and enable you to get closer to a subject without anymore zooming.

RIGHT:
Using filters opens you up to some intriguing effects.

LEFT:
Lens converters
add depth and drama
to your videos.

As with filters, lens converters fit onto the end of the camcorder lens, and for the more ambitious videomaker there are special converters, such as a fish-eye, which is an ultra wide conversion lens.

LIGHTS

You have two options: lights that are on the camcorder (either built-in or ones you attach), or external lights. Lights can be used simply to lift the gloom of a shot, so you can ensure you get detail in the picture. However, they can also be used to add atmosphere. Lighting an interview subject a certain way can increase tension and intrigue. Likewise in fiction you can evoke the right mood of horror, comedy or drama.

On camcorder lights have a limited value, so it's better to plump for a small lighting kit, if you are intent on producing high quality results. Accessory companies offer starter kits, which usually include three "redhead" lights – the most generally useful type of light – and perhaps a stand and reflector. The more ambitious your project the more specialist lights you will need. Check our useful addresses section for lighting suppliers.

BELOW, LEFT TO RIGHT:
Lights come in many
shapes and sizes –
on-camera, stand-
mounted or hand-held.

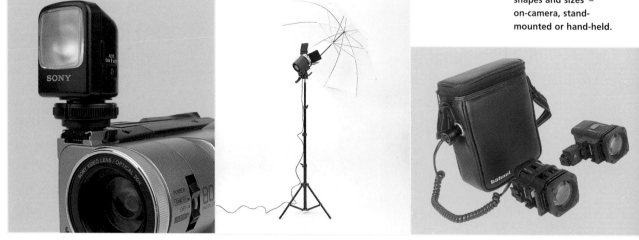

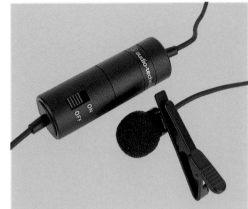

MICROPHONE

The purchase of an external mic (make sure your DV cam has an external mic socket) frees you from the shackles of the in-built mic. Two types are available: dynamic and electret. The first requires no battery. A coil attached to its diaphragm is moved by sound waves and vibrates between the poles of a magnet to produce an electronic signal. Ideal for quiet locations, as the mic itself generates little noise, such as interviews and narration. Electret mics need a battery to power a built-in pre-amplifier

that consequently boosts the signal. They are powerful and also more sensitive than dynamic mics. Overly loud audio can overload them, and they produce some noise themselves. Within these two types of mic there are several pick up patterns, which show the mic's angle of sound acceptance: Omnidirectional – picking up sound equally from all directions Cardioid – sound picked up from the direction the mic is pointing Super-cardioid, Hypercardioid – more directional than cardioid, these often reject sounds coming from behind or the side.

HEADPHONES

Essential for monitoring the sound you are recording. The ear is a sophisticated piece of technology that can filter out the sounds you don't want to hear (insert sexist nagging joke here!). Even expensive mics can't always do this. Make sure you know what's going down on tape. Ensure your camcorder has an external headphone jack before purchase though.

TAPES AND BATTERIES

Small enough to forget yet you'd be lost without them. A supply of tapes, and a selection of charged batteries is essential for any production, whether it be holiday, birthday, fiction or

BELOW:
The Mini DV tape takes up almost no space.

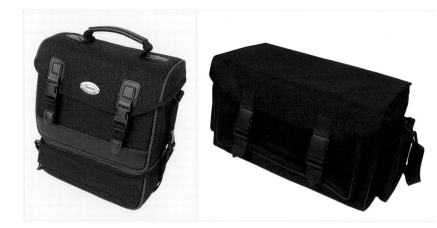

documentary. DV tape is affordable, more so when bought in bulk. Batteries are more expensive but you should invest in a separate charger and at least one extra battery.

CAMCORDER CASES AND BAGS

Think of your camcorder as a vulnerable possession – and make its home a pleasant one. Twee, we know, but it's easy to get blasé and forget just how much your camcorder cost you. Bags should be heavily padded and have space for plenty of tapes, batteries and accessories. The less ostentatious your carrier, the less likely it is to find itself in a bag marked swag.

DOLLIES, CRANES AND TRACK

Bonjour Monsieur Professional! Dollies and cranes offer videomakers the chance to get incredible footage. However, it comes at a cost. You need to ensure you have a use for these expensive goodies. Dollies are "vehicles" that can be pushed along a plastic or metal track in order to follow action – hence the phrase tracking shot. But dollies don't need to be pro set-ups they can be any wheeled platform that allow the camcorder and its operator to keep up with the subject. Unless you're intent on recreating the crowd scenes from *Gladiator*, it might be worth keeping cranes to your bigger productions. Excellent for sweeping ground to air shots, or shots from extreme angles, these are costly and need a team of operators, plus an external monitor to view what you're shooting.

ABOVE:
Stay secure. Protect your camcorder when it is not in use.

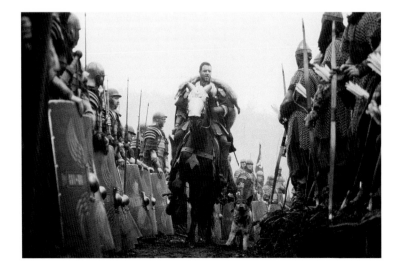

LEFT:
Supports such as dollies provide interesting shots as in *Gladiator* (2000).

2

The Basics

The Basics

BASIC CAMCORDER FUNCTIONS

Despite the prolific number of camcorder designs available to consumers, there are many key functions which are incorporated (to varying degrees) on all models. Here we have listed the most common buttons and controls you will find your fingers heading towards, along with a description of what they do and whether they are any good or not!

AUTOMATIC SETTINGS

All digital camcorders, whether they are expensive or cheap, include automatic functions, which are activated as soon as you turn the camcorder's power on. This is where the term **point and shoot** comes from, as these auto settings take control over focus, exposure levels, white balance and shutter speeds. The videomaker therefore has nothing to do but point the camcorder in the direction of the action, and press the big red record button!

While the sophistication of automatic systems has increased, the level of performance can fluctuate, and relying totally on auto pilot often results in footage which, though acceptable, could be so much better. In many cases, the automatic systems simply cannot reproduce the shot you are after. Examples of this include shooting in low light conditions, starting to shoot indoors and then moving outdoors, as well as pull focus shots.

FAR RIGHT:
Automatic white balance becomes a problem when mixing light sources.

RIGHT:
The camcorder will automatically focus on subjects closer to it.

In low light the digital camcorder's circuitry boosts the DV signal in order to add detail to the picture. Therefore, when it is dark or gloomy, the camcorder tries to increase the light. This is often

referred to as **gain**, or **gain-up**. Unfortunately, when it is trying to increase detail, the camcorder only promotes picture noise (grain) and the quality of the image degrades.

Capturing the right kind of light is very difficult. Our eyes are sophisticated at reading colour, camcorders are not, and can easily be tripped up by changes in colour. Most of what we see is a result of reflected light, ie not many objects generate their own light (the sun and artificial light being the main "sources"), and therefore the colour of an object is dependent on the colour of the light source and its own physical properties. Indoor artificial lights have a yellow/orange cast, while natural light is blue. Moving from one to the other using a camcorder's auto white balance setting will result in the colour of objects not always being true, as the camcorder boosts the intensity of colours to compensate for the changes in light.

Auto focus systems can also be hindered by rapid movement. If the camcorder does not have a speedy auto focus, then you will be left waiting a fraction of a second longer than necessary for objects to come into focus – this is commonly known as **hunting**. Using auto focus can also create problems when the subject of your shot is not at the front of the frame. Camcorders will generally concentrate focus on the first substantial object they see, leaving the background of the shot out of focus. In most situations, the auto setting will offer a large depth of field, whereby most of the frame is in focus. However, if, for example, you were shooting with railings or a fence in the foreground then it could prove difficult keeping what is in the background of the shot in focus if you relied totally on the auto focus system.

Pull focus is a common technique used in film and video production. It essentially sees the focus change from one object to another within a sequence of footage. It helps concentrate the audience's attention on what is important, and helps to convey a point without recourse to dialogue. Imagine a wine glass in focus at the front of a shot, gradually the glass goes out of focus and the background comes into focus, revealing a character opening a bottle of wine. It would be impossible to create this shot using auto focus.

MANUAL FOCUS, EXPOSURE, WHITE BALANCE AND SHUTTER SPEEDS

Manual systems allow you to tell the camcorder what you want to see. Initially this might lead to images that are not exactly what you would expect, but once you become au fait with exposure, shutter speeds and white balance, it is possible to get very creative.

Very few digital camcorders lack any manual functions, though many budget models will only include manual focus. Selecting manual focus is usually done by pressing a button on the exterior of the camcorder to engage the mode. The user will then control focus by rotating a manual

ABOVE:
Using auto focus can result in your camera "hunting" for an object to come into focus.

RIGHT:
Manual controls, such as focus and exposure, allow more shooting flexibility.

RIGHT:
Even tranquil scenes can benefit from careful use of manual controls.

to as the aperture, and is a round hole behind the lens. To restrict light entering the lens when the conditions are too bright it needs to be closed. If the light is too low, then this aperture needs to be opened to make the most of what light there is. The size of the aperture/iris is measured in numbers known as **f stops**.

Domestic DV camcorders will generally have a wide selection of f stops controlled automatically and manually on entry-level and enthusiast models. Having control over these yourself provides much more flexibility for the user.

focus ring around the lens barrel, or a small thumbwheel on the left side, or back, of the camcorder. Manual focus rings are the best system for controlling focus as they are larger and easier to use than thumbwheels, make less noise (which can often be picked up by the camcorder's microphone) and are more sensitive. Unfortunately, it is rare to find focus rings on budget camcorders, they seem to be the preserve of true enthusiast machines. The reasons for using manual focus have been well highlighted in the Automatic Settings section.

Seizing control of white balance, exposure and shutter speeds is predominantly done via a DV camcorder's menu system, though a thumbwheel, or selector dial, is used to control the exposure or shutter speed rate.

Using manual exposure and white balance settings allows the user to compensate for light or dark shooting conditions, and, in the case of white balance, to record colour accurately. To make the best of these features, the user needs to control the amount of light entering the lens. Too much light and the picture will be over exposed, too little and it will be under exposed. The camcorder's iris and shutter speeds are essential to this control. The iris is often referred

As for the shutter, well that is a term picked up from stills photography. The shutter itself is actually an electronically controlled device on camcorders, situated behind the aperture. It opens for a split second to let light through and then closes to block it out. The speed at which it does this is known as **shutter speed**. On domestic DV camcorders the standard shutter speed is 1/50th of a second, but this can be changed with a manual function to speeds in excess of 1/8000th of a second. The benefit of being able to change shutter speeds is seen when you move away from shooting "standard" footage.

Variable shutter speeds are a must for capturing fast-moving action such as motor sport or football. Using a standard 1/50th shutter speed here will result in blurred footage, still sharp, but blurred.

There is a downside to using higher shutter speeds though. You have altered the amount of light coming through the lens and so you need to be in brightly lit conditions to see the best of it. There is also the problem of jerky footage, as sports footage is often slowed for slow motion replays or blur-free frame-by-frame analysis. Hence camcorder manuals' fondness for pointing out how great high shutter speeds are for improving your tennis serve or golf swing!

Manual white balance might also mean you have to carry a selection of coloured card around with you! Setting white balance manually involves placing the camcorder in the right mode via the menu system, pointing the camcorder at a piece of white card or paper and setting the white balance level. This tells the camcorder what is white – and it then relates the setting of colours to this. However, in order to be more creative, you can "trick" the camcorder by using different shades and colours.

PROGRAM AE MODES

Program AE modes are included on all digital camcorders. They are pre-configured auto exposure settings designed to cover the most obvious shooting conditions, such as sports, portrait, landscape, low light, spotlight, sunset, ski and snow.

An easy fix, should your digital camcorder not have too many manual functions, they are either hidden away in the camcorder's menu system or incorporated on a dial on the back, or side, of the camcorder.

ABOVE:
The AE menu provides sports mode to capture fast-moving action.

BELOW:
On sand or snow, beaches and skis, AE modes help to compensate for extremely bright light.

THUMBWHEELS, DIAL AND SELECTORS

Every camcorder manufacturer has different design criteria, but all make use of thumbwheels, dial and selector switches. The miniaturization of digital technology has meant these controls are smaller than ever before, and can be frustrating to use. Thumbwheels, etc, usually control the selection of program AE modes, focus, exposure and digital picture effects.

TIMECODE

Hidden away in the maze of DV camcorders and their menu systems, writing timecode to your footage is vital for editing purposes because it enables every recorded frame of video to be numbered. A number representing hours, minutes, seconds and frames is recorded to tape. Camcorders record 25 frames per second, so, for example, one frame of video will be timecoded as 00:15:46:02 and the next frame will be 00:15:46:03.

RIGHT:
To make the best use of the zoom feature zoom in before press the record button.

ZOOM

Optical and digital zooms are included on all DV camcorders. Optical systems can run up to 25x magnification, while digital can exceed 700x, but the latter will result in image degradation. Zoom controls are always on the exterior of the camcorder and usually take the form of a lever or a rocker, moved to the left or right (in and out).

It is advisable for the zoom to be used sparingly as it does not look attractive or professional in videos. It is better to zoom in on your subject before pressing record.

RECORDING BUTTON

Usually the big red button on the back of the camcorder and too obvious to miss. Some camcorders have a protective flap across the record button which needs to be flicked back before the camcorder can be switched on and recording can take place. Other models will have a switch or dial that needs to be moved to "On" before the recording button can be pressed.

IMAGE STABILIZATION

Two systems are available, optical and digital (see Buying the Right Camcorder) and both offer a convenient way of steadying camera shake when you do not have access to a tripod – though this remains the most professional way of achieving smooth footage. Image stabilization can make footage appear jerky. It is located in the camcorder menu system.

Digital and Picture Effects

Competition within the camcorder market has led to an increasing number of digital effects being included on even the most basic digital camcorders. Essentially, these are gimmicky features which are cheap to include and look enticing, but which have limited practical use.

Typical digital effects include: sepia, negative, classic film, strobe, gain-up, trail, solarize, black and white and mosaic. The effect is selected before shooting and then applied to the footage, ie. sepia will add a brownish, old fashioned tinge to the video, negative will reverse colours, solarize enhance colours to give the look of a poster, while mosaic does exactly what it says – and consequently is not used that much!

Hidden away in the menu system, digital picture effects can also include more useful settings such as scene transitions. Fades and wipes can be selected and therefore a scene can be faded in from black or white. Wipes can see the scene start by sliding in from the left, right, top or bottom of the frame.

More advanced digital camcorders in the entry-level and enthusiast sectors allow users to apply digital effects on recorded footage.

LEFT:
Adding picture effects, such as negative or mosaic, can give your images a completely different spin.

DIGITAL STILL SNAPSHOT

Incorporated onto all digital camcorders this is a way of storing still images. A photoshot button is situated on the exterior of the camcorder and when pressed will record a digital snapshot onto either a tape or a multimedia card, if the camcorder supports it. Recording to tape limits the quality to 640 x 480 pixels resolution (VGA quality) and usually sees the snap recorded for around six seconds, with accompanying sound if there is any. Recording to multimedia card can mean improved quality, with more sophisticated enthusiast camcorders offering megapixel picture quality, which is closer to the standard of traditional 35mm film.

It is possible to transfer these image onto a computer via RS232 or USB connections, and again, many camcorders include image manipulation software to "play" with the images once they have been transferred onto a computer. PC software is more readily supplied than Mac software.

NIGHT-SHOOTING FEATURES

Aside from your DV camcorder's ability to shoot in low light conditions, it might also incorporate a near-darkness shooting mode. Sony's system is called NightShot, JVC's NightScope and Panasonic's NightView. Essentially, they all offer the same; recording in very low light conditions. This is beneficial if you are intending to video nocturnal wildlife, use your camcorder as a motion sensor in a security situation, or if you want to get a shot of your child sleeping peacefully at the end of a hectic birthday! Sony and Panasonic's system will provide slightly ghoulish, greenish images, with a white effect on the subject's pupils, but they are generally smooth. JVC's system will provide colour images, but, due to a long exposure time, any movement within the shot will appear blurred.

BELOW:
Because low light conditions add grain to your images, night shooting features can come to your aid.

Progressive Scan

Only available on a limited number of camcorders, Progressive Scan offers a way of capturing sharp, blur-free moving and still images. The fields and frames that make up a single camcorder image are de-interlaced. The resulting image is ideal for analysis in a frame-by-frame manner, though moving Progressive Scan footage does exhibit jerky movement. Both Canon and Panasonic make use of Progressive Scan on their digital camcorders.

Basic Camcorder Maintenance

Although you might want this to be the longest section in this book, we are sorry to say it is going to be one of the shortest! Camcorders are intricately engineered and we cannot recommend that you attempt any maintenance yourself.

Mini DV camcorders are even more sophisticated than their analogue counterparts, so we would suggest you always seek the advice of a qualified engineer if your camcorder starts to malfunction. There are simply so many things which can go wrong on a digital camcorder it is not worth giving yourself sleepless nights over them. The majority of retailers and dealers will offer some kind of repair service, as will all the camcorder manufacturers, if you contact them directly, while there are also independent engineers you can find through the *Yellow Pages*. It is also useful to remember that the Internet, through newsgroups and message boards, is an excellent resource, and allows you to converse with like-minded individuals. Remember also that tinkering with your DV camcorder invariably invalidates its warranty, so if you do decide to have just a bit of a fiddle, think about the cost of having to buy a new digital camcorder, as opposed to the cost of having one repaired!

ABOVE:
A padded bag is a secure way of transporting your valuable equipment.

Take Precautions

Although tinkering with your DV cam is not recommended, there are several precautions you can take to limit what might go wrong. These range from the obvious to the still-fairly-obvious-but-very-easy-to-forget!

Despite claims that your tiny DV camcorder can fit into your shirt pocket, this is not always the best place for it! Try to ensure you have a heavily padded pouch or case for your camcorder to protect it from bumps and knocks while you are travelling with it. Buy either a lens cloth, or brush, from a camera manufacturer to remove small dust and dirt particles from the lens. The lens is one of the most important parts of your camcorder: help to preserve it.

LEFT:
Carrying out simple maintenance, such as cleaning the lens, will be allowed in the warranty, but do not tinker with the insides!

If you have been shooting in the rain, even with a rain jacket covering the camcorder, make sure you leave the camcorder to "dry out" at home, before recording or playing back footage. Condensation has proved to be the cause of a large number of faults.

Reading the technical specifications of your digital camcorder (as you do!), you will often see details concerning the camcorder's operating temperature. Manufacturers, to cover themselves, suggest that camcorders should not be used in extreme conditions: hot, cold or damp. However, it is possible to use digital camcorders in these conditions, provided you are careful with them. Make sure you take protective covers and rain jackets where necessary, and try to avoid going quickly from one extreme situation to another.

Perhaps the best precaution you can take with your digital camcorder is to have it insured. Check with your home contents insurance provider to see if your camcorder is covered, needs adding, or requires a separate policy. As with many insurance policies, make sure you read the small print to ensure your camcorder is covered for trips abroad, as well as at home.

A Few Words about Widescreen

About ten years ago you probably noticed that an increasing number of films were being released on video with a choice of two formats – ordinary or widescreen. Now, despite having become more and more popular over the years, there are still people who, the moment you begin playing a widescreen video, will say: "I hate those black bars on the screen."

Even with the spread of widescreen format televisions, it is still not uncommon to find people who dislike the widescreen look. They may own a widescreen television, but the distinction between pan-and-scan and 16:9 is a stranger to them, and even the first hint of a

ABOVE AND RIGHT:
Widening the horizons. New technology in television means that widescreen will soon become the normal viewing medium.

letterbox effect onscreen will provoke a grumpy tirade.

It is incredibly easy to talk people out of this viewpoint, especially with the appropriate visual aids (two TVs, two VCRs, side by side, showing both a widescreen and an ordinary pan-and-scan version of the same film) and quite often you will find that they become fanatical converts to the world of widescreen. First, however, you have to explain what those black bars are, why they are there, and what effect they have on your videomaking.

A Potted History of Widescreen

The trouble all started back in the early days of cinema when the film stock used to make movies had a width to height ratio that made it approximately square. Over the years this aspect ratio changed to more rectangular choices of 2.35:1, 1.85:1 and 1.66:1 ratios that became popular among filmmakers for the extra width in framing it allowed and the consequent "epic" look it enabled. The popularity of these wider ratios (we'll just use 1.85:1 as an example) soon sounded a death knell for the older, narrower Academy ratio, although a few notable films were made in the older ratio even after its

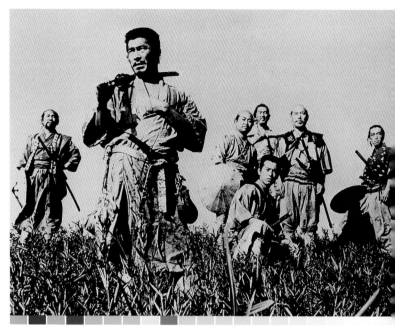

decline had begun (*Seven Samurai*, for example, displays some of the best image composition in cinema history, despite using the narrower Academy format that was already near enough defunct by the time of its 1954 release in Western cinemas).

Meanwhile, as film ratios were widening, another development was in progress – the TV, or idiot box. By fluke of circumstance the mechanics of the cathode ray tube and its electron gun reached a very similar aspect ratio as the squareish academy format. The limitation on the distance from which the electron beam could "paint" its pictures on a television screen meant that a 4:3 aspect ratio became the default for screen ratios on TV sets.

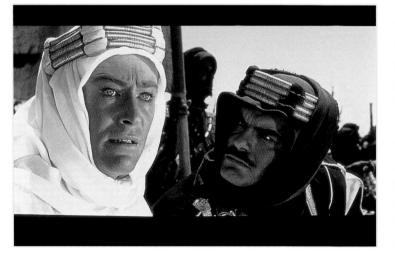

ABOVE AND BELOW:
Seven Samurai (above) and *Lawrence of Arabia* are often praised for their epic scale and brilliant composition, despite their very different Aspect Ratios (1.37:1 and 2.20:1, respectively).

Modern Television Receiver Design

version of the same film have to be separately assessed by a certification body, causing an extra expense which is invariably passed on to video purchasers; secondly, the intentions of the director and cinematographer are lost, as someone separate from the original filmmaking process reframes the shots; and thirdly, it creates people so used to seeing pan-and-scan movies that when the addition of black bars to the TV screen is made in order to recreate the original wider ratio they promptly turn into whingeing ninnies who demand a full screen picture, despite the fact that they will lose a chunk of the film that they are trying to watch.

The black bars that cut down the height of the visible screen area are often referred to as being part of the widescreen aspect ratio, although to be perfectly honest they are actually in a ratio, usually, of 16:9, which is a close, but not completely accurate, approximation of the cinema 1.85:1 ratio. Do not knock it, it is so close that it makes no odds, and, in any case, it is miles better than pan-and-scan. (When purchasing videos marked widescreen its often worth checking the aspect ratio on the back – they will often be in 16:9 format, but if you're really lucky many widescreen videos will actually increase the black bars even further to give you an accurate 1.85:1 ratio.)

Additionally, many broadcasters show their programming in a 14:9 ratio that strikes a balance between the width of the image and the amount of black barring used to letterbox the screen into a wider ratio. Most of these broadcasters will only accept footage in a 16:9 ratio, so be warned that 4:3 footage will either require much post-production work or risk being considered redundant.

Consequently, images shot on the wider 1.85:1 ratio of film have had to be panned and scanned in order to bring the most important parts of the cinematic image to the four units high by three units wide television screen.

The pan-and-scan process takes place using a process similar to the telecine process that transfers film to video – an operator pans around the film image to find the most important part of the image and then scans that, creating a 4:3 image and discarding the rest. This has the effect of either losing elements of the original picture composition or forcing multiple pan-and-scans of different areas of the image to be used consecutively, giving a scene that was originally a single shot take the appearance of being composed of several different shots.

This leads to three very annoying side effects – firstly, both a widescreen and a pan-and-scan

WIDESCREEN VIDEOMAKERS

So where does this mess of ratios leave video-makers who are working with camcorders that default to a 4:3 ratio despite the encroachment of widescreen TVs into the market? Not in too bad a position, actually. There are several ways of tackling the issue, all of which have their pros and cons that can provoke a stimulated debate between fans of one process or another. It is simply a question of deciding how you wish to go about things.

Should you decide to shoot in 4:3 then no problem, you are ready to go. Should you want to use 4:3 but are worried that you might want 16:9 later, take heart, as long as you frame your shots with the 16:9 ratio in mind it is possible to ARC (aspect ratio convert) your footage later, either at a post-production house who will do it for you, or by searching out and downloading an ARC plug in for your computer's Non Linear Editing software and then letting your poor computer spend several hours rendering the footage into a new format.

The problem of covering your back in this way is that around 25 per cent of your footage is being thrown way in post production as your image is scaled to a wider, less tall format. This means not only having to run the risk that a slight error in framing may render your footage useless, but also, according to some, that it will suffer a drop in quality by wasting the image processing resources of your camcorder on footage that will be discarded rather than by applying the full bandwidth to the important stuff.

There are, of course, other options available to those who want to achieve 16:9 footage. Starting with the camcorder itself, look at the instruction manual and look for either 16:9 or Cinema Mode under the list of digital effects.

The image chip (or chips) in most digital camcorders is already 4:3, but the digital effects can go some way towards creating a 16:9

appearance. Unfortunately, there is no standardization for the names of digital effects, which means that you will have to read through the manual in order to discover whether your camcorder's "Cinema" effect is a widescreen shooting tool or simply an imitator.

Cinema usually refers to an effect that places black bars on your footage in order to create a 16:9 look. This is the poor man's widescreen and, although interesting, is of no real benefit to someone interested in true 16:9.

Should your cam actually have a true 16:9 function, it will take one of two forms. The first is an inbuilt ARC capability that will adjust your 4:3 footage to 16:9. If your cam has this function it should also provide you with some sort of visual guide to aid your widescreen framing within a square viewfinder. If it does not then a pair of carefully placed strips of gaffer tape and a lot of cautious composition should be applied.

The other 16:9 option sometimes found on camcorders involves the actual de-activation of pixels at the top and bottom of the CCD in order to create a 16:9 ratio in the remaining pixels. This is both a blessing and a curse – on the positive side you will be capturing a 16:9 image, on the negative side you will be starting with a lower pixel count and consequently running the risk of losing detail.

The final practical option for obtaining 16:9 images is the anamorphic lens. If you look at the front of your camcorder you will notice a thread on the inside of the lens barrel – this can be used for many things, including the matte boxes, slide adapters and, most importantly for this chapter, an anamorphic lens (sometimes an anamorphic lens will require the addition of a supporting bracket, or a stepping ring, to overcome disparate thread diameters between the lens and the lens barrel). This is probably the most expen-

ABOVE: **An anamorphic lens, which can be attached to your camcorder.**

sive method of capturing a shot in 16:9 (short of actually buying a broadcast camcorder equipped with widescreen image sensors), but it is also the one which provokes the least debate.

The only real drawback to using an anamorphic lens is that it will slightly cut down the zoom and focus ranges of your camcorder. Seeing as how zooms during shooting tend to be distracting and hideously amateurish, this is not too much of a problem: you will only be using the zoom for pre-shot framing and the old rule will apply – if your subject is too far away then move the camera closer. The same thing applies to focus: you will have taken care of it before starting your shot and will have worked around any minor problems using methods to be explained later in this section. Put simply, the drawbacks of an anamorphic lens will only catch you out if you let them; pre-planning will mean that they are not a problem at all.

Any problems that do occur will be at the widest angle setting, so a minor zoom should solve the problem and remove the possibility of the anamorphic lens cutting off (vignetting) part of the image. Vignetting also tends to occur

more with larger depths of field, so a little playing with your cam settings may solve the problem – depth of field can be reduced by increasing the aperture size and adjusting the shutter speed to compensate for the increased amount of light hitting the CCD.

The anamorphic lens (A-Lens) is similar to a traditional wide angle lens, but with one important difference: whereas a wide-angle lens will both widen and heighten your view (and transfer both width and height back to the CCD) an A-Lens only increases the viewing width, expanding the width ratio without affecting the picture height. These new, wider images are then squeezed onto the CCD of the cam ready for later viewing.

Most widescreen television sets, and many VCRs, will happily deal with the anamorphic lens recordings automatically, and although some 4:3 sets will produce a distorted image when trying to deal with anamorphic footage, many modern ones will have a setting that adjusts the available picture area of the screen in order to deal with the new footage.

Some compatibility issues may arise when sending anamorphic footage to an NLE system, but many of the more advanced systems, although unable to recognize the difference between 4:3 and anamorphic automatically, will have a selectable project setting intended for dealing with exactly this type of footage. Once again, there are always third-party plug-ins available should your NLE system need a helping hand.

Widescreen footage is both visually impressive and, in many cases, a prerequisite for being broadcastable. Daunting though it may be for videomakers to try adjusting their 4:3 consumer cams to the 16:9 ratio, it is always worth the effort. Play around with a few of the different options available and we guarantee that you will be pleased with the wider look.

Anamorphic lenses can overcome the narrow Aspect Ratio of a camcorder's image chip.

3

Skills

Skills

COMPOSITION

Proper composition is an invaluable aid to videomaking, and should be regarded as much a tool as a tripod or video light. Careful thought about the layout of your shot, what will be in it and where it will be, can make an incredible difference both to the look of your film and to the feelings your images convey.

If composition was not vital, then Orson Welles would never have ripped up the floorboards to get a worm's eye camera angle on Charles Kane, communicating the man's imposing presence in a way that renders dialogue unnecessary.

As if composition was not important enough as a storytelling tool, then it is worth remembering that badly composed shots can ruin a good film – it may seem like a good joke to position someone so that the trees in the background appear to be sprouting from your subject's scalp, but in fact it is little more than a bad pun, at best a distraction and at worst an amateurish mistake.

Fortunately, there are rules and guidelines you can follow in order to create well-composed shots. For a dramatic videographer telling a fictional story, there will be time to plan shots with these rules in mind, for a documentary maker capturing video on-the-fly, good composition will not always be possible. The rules, however, will become second nature very quickly, and even if pushed a good videographer will be able to apply them instinctively. Of course, once you have this much grasp of the rules you can begin trying creatively to break them!

THINK AHEAD

Early planning is helpful both for avoiding common composition mistakes and for getting the best out of your location – it is vital to know what you want to shoot in order to make sure you shoot it correctly. Having established a list of things you wish to commit to tape, you can work out where you will position the cam for a "safety" or master shot and figure out what other shots you will need and what they are supposed to accomplish.

Knowing what your shot is intended to convey will help

you plan its composition – there is no point having a shot in your finished work that is simply there because you had it on tape. Knowing that the subject of a shot needs to appear menacing, or dynamic, or serene will help you work out how the shot must be composed.

When you get to your location, try to see the shot the way your camcorder will: look for unlit objects, size discrepancies, obstructive items of scenery, things that are eyecatchingly bright and just about anything that will call unwanted attention to itself. Items like this are an inconvenience only if they go unnoticed until you have already shot. If you check things out beforehand you can turn annoyances into advantages – the obstructive branch right in the middle of the frame can be turned into useful foreground interest with a quick repositioning of the camcorder.

RULE OF THIRDS

Having disposed of, utilized or worked around potential trouble-spots, you can begin compos-ing the shot with the camera. The most important guideline in composition is the rule of thirds, a guide that constantly comes in handy by making your shots look well balanced via the odd method of deliberately putting them together along unbalanced lines.

The most important item in any shot does not necessarily have to be at the centre of the frame, in fact, short of attempting to dominate an entire shot, it is generally best to avoid placing your subject dead centre as it will prevent your viewer from being able to relate anything else in the shot to the actual subject.

Imagine a shot of a landscape with the horizon falling dead centre across the screen – are you supposed to be paying attention to the land or to the sky? Instead, try to allocate two thirds of a frame to one part of the shot and the other third to the remainder. Imagine the screen divided into thirds across the horizontal and vertical in a grid – the intersections of these gridlines are usually the best place to position your subject.

Using the rule of thirds, composition will provide a natural-looking asymmetry to your footage rather than a staged and arranged look. Additionally, it serves to draw the viewers attention to where it needs to be whilst allowing the subject, foreground and background to complement, rather than compete with, each other.

PERSPECTIVE AND POINTS OF VIEW

Another point to keep in mind when filming is the nature of the medium – there is no point filming the three-dimensional real world and expecting it to have depth when played back on your 2D TV screen – you have to create the depth yourself.

Perspective problems can easily be solved with a little thought about camera placement. Extra depth or better perspective can be added to a shot simply by engineering it so as to avoid common pitfalls and make use of the available space.

Think of a tall skyscraper – a common mistake is to film it head on. It is an understandable error: filling the screen with the subject seems like a good way of conveying the building's scale and presence. Unfortunately, you will find that, rather than dominating the shot, the undynamic presentation of the building will make it appear little more imposing than a pile of bricks.

To make the scale of the building more apparent you should drag your camera to one of its corners and shoot from there – automatically adding a vanishing point to your shot as the facade of the building recedes into the distance and allowing other items into the shot to give a sense of relative sizes.

Another trick using the example of a building is to place your camera near the foot of the building and shoot upwards. The change of angle will allow the building to loom overhead and with careful framing you will get a natural border of sky which will start off narrow and

RIGHT AND OPPOSITE: A dramatic camera angle and a bit of foreground interest make these shots much more dramatic than a simple head-on perspective could.

widen as distance "shrinks" the building – the dwindling upper floors of the building combined with the expanding frame of sky will impart the size of the building effectively, and the more dramatic the effect the more visual representation of size you will get.

Looming buildings are just an example, of course. These rules can be applied to pretty much anything. People, however, may object to having their double chins in shot as you crouch at their feet shooting upwards, and shooting from the side may make them uncomfortable, especially in drama, where actors have to appear ignorant of the camera's presence – they know you are there, they know you are doing something, but they are not allowed to look. Not knowing what is going may cause self-conscious subjects to cast sidelong glances at your cam. That is not to say you cannot shoot people using these methods, but it may be better to experiment with other methods, especially if your subjects are saying or doing

things that will not be picked up from low or diagonal angles.

Adding foreground interest is a good way of adding perspective to a picture where clever camera angles cannot be used. Simply relocate the camera to incorporate a naturally occurring object in the foreground or add a prop to accomplish the same effect. This has the added advantage of allowing you, if necessary, to drag the viewer's attention from object to subject by opening up the depth of field or doing a quick focus pull.

If you can't find a suitable foreground object for some reason (say there is nothing, or what is available would be too distracting) then try moving your subject to somewhere that provides a naturally occurring frame. This way you can add interest and a sense of scale to your shot without having any distractions in the foreground. Doorways, bridges, a corridor of trees, all of these will naturally frame your subject, drawing attention to the relevant part of the image in a pleasing, but non-distracting, way.

The naturally occurring frame has another bonus to it should you want to play cute with your footage – it allows you to manipulate contrast levels within the picture. An internal shot of a doorway can provide a dark border to a sunlit street, whilst an external shot through a doorway into a darkened interior can add a touch of menace to an image.

Natural frames also provide another way of messing with your audience's perceptions, albeit in a risky fashion. Say, for example, you have a distant building and you frame it through the legs of a stone seat – with careful planning the shot can look as if it has been taken through a massive archway rather than through a narrow space – meaning that objects appearing in the mid-ground between frame and subject will appear to be out of proportion with their surroundings. This sort of gimmick can add novelty value to your shots but should be handled carefully – the line between amusing trick and terribly misjudged shot is a thin one, and one that is easily crossed.

Speaking of crossing lines, do not. This is another rule as fundamental as the rule of thirds. Say for example you have two people talking to each other, one on the left of the screen, the other on the right. Imagine a line drawn between them – should you shoot from one side of the line and then shoot from the opposite side your subjects will appear to have swapped sides despite not having moved. This will be noticed by your audience and will instantly shatter their illusions. Either pick a side and stick to it, shoot the conversation using "over-the-shoulder" shots or carefully combine the two using the shot of both subjects as a safety and over-the-shoulder shots as inserts.

Not crossing the line in a simple, two-person shot is fairly simple, but becomes more complicated when extra people are added. Think of the diner scene in *Reservoir Dogs*, or the post-trial pub gathering in *Trainspotting*. Both scenes are fairly minor in terms of their importance to the overall story, but try watching those films

LEFT:
When filming a conversation, make sure you don't "cross the line".

people will speak their lines and where your camera will be placed for the very first shot. That is the point where the first of many "lines" will be established and the place you have to build the rest of the scene from.

Draw a diagram of the scene to plan things out. If you are filming from the head of a table and are starting with a conversation between two people opposite each other

with a gaggle of film buffs and those scenes will invariably draw comment for the way they handle conversations between large groups of people without accidentally crossing the line in an attempt to get the relevant speakers in shot.

Careful planning of group shots can be a subtle way of drawing appreciative comment from savvy fans, but it is also a minefield for the unwary and requires meticulous planning to get it right. Think about where your speakers and addressees are sitting, the order in which different

before moving on to a conversation between people side by side, you will have to move your camera to the opposite side of the table, to avoid having one subject obscured by another. This is where you might cross the line. There is no way around these risks apart from painstaking shot planning. Even with pre-planning make sure you have a safety take and inserts ready so that any disaster with your bravura crowd scene can be rescued in the edit suite by substituting a more conventional approach to group conversations.

MOVEMENT

Moving objects also require careful composition, mainly to avoid glaring mistakes that will upset your audiences ability to immerse themselves in your drama or distract them from the points you are trying to make in a documentary.

Always allow for both moving and looking room within your shots – we have all been annoyed by a bad mime act doing a naff "walking-against-the-wind" performance. That is the effect you will achieve if you don't allow room in your shots for events to happen. If you are panning or dollying alongside a walking person or moving car then allow them room to move into. A car moving from left to right across the screen should be framed with space to its right and this space should be kept until the point when the camera movement stops, allowing the car to move naturally out of shot. Should you fail

to allow enough room the car will run into the edge of the screen and the sideways movement of the camera will look as if it is being "pushed" by the car. Rule of thirds can be used to great effect here – line up a right-moving object on the left-hand thirds and you will avoid the push effect and will not appear as though you are struggling to keep pace with the subject.

Try to avoid too many cuts in a shot featuring moving subjects – allowing a subject to progress partway across the screen and then cutting to a later shot where the movement is even more advanced will provide a noticeable and annoying jump in the action, a jump cut. Should a movement be taking too long to complete try fading slowly between cuts to truncate the shot in a much more artistic and less jarring fashion.

Moving room also applies to slower shots such as someone walking toward the camera –

RIGHT:
Remember to stay just
ahead of the subject,
especially if you
are trying to give your
audience a feel for speed.

if you fail to allow space between their feet and the bottom of the screen they will appear to be walking on thin air – make sure they have some foreground to walk into.

Slower movements require even more careful composition. A simple left to right framing of a moving object is fine for conveying that object's speed, but something that moves more slowly will lack dynamism as it moves flatly across the scene without any change in perspective. Try using a diagonal composition – a person enters a room at the top left and moves diagonally to exit bottom right, allowing them to grow in stature as they approach the camera and giving your audience the chance to examine the subject head on.

UNNECESSARY AMPUTATIONS

Speaking of heads, remember to allow headroom for people in shots. Be it an immaculate £300 haircut or the mullet from hell you have no business cutting off people's hair. Frame headshots with a noticeable gap between the top of someone's head and the top of the image to avoid an amateurish mistake. Alternatively, should you be going for a big close up on a subject's face that makes some loss of the subject inevitable, then try to cut off a significant amount, making the close up much larger and ensuring that any loss of the subject is clearly deliberate.

The rule of thirds makes itself useful here yet again – the most important part of any headshot is usually the eyes – place them on the uppermost line of your rule of thirds grid and you will have a well-balanced and natural-looking image without chopping off the head or the other alternative of leaving too much headroom and causing your subject to look pint-sized.

Similarly, try to avoid shots that cut people off across naturally occurring joints, a person framed with the bottom of the image cutting off across their waist will look like they have had a nasty accident. Try to make the edges of your image fall across limbs partway between joints – cut off at mid-thigh rather than at the knees, for example.

Weightings are another important part of composition, and a very subtle part at that. All items and locations have different effects on the eye, and these effects can be assessed and exploited. Warm colours, such as red and orange, will attract the viewer's eye more effectively than colder blues and whites. The placing

of objects also carries a certain weight – pick up an advertising directory and check out the most expensive areas of a page you can buy – you will soon notice that top right-hand spots are the most coveted and highly priced because the eye naturally tends to fall in that location. This rule is less true with a moving screen image than a static page, but it still applies to a certain extent, and should be kept in mind.

Most rules of composition are there for one of two reasons – to add a dramatic visual element to your story, or to avoid a visual trick that will disrupt your audience's ability to suspend disbelief. Like all rules in videomaking, there are times when the rules can be broken to good effect, but it takes an experienced eye to know when to do so. In general, it is better to be safe than sorry, so if you are going to break the rules then make sure you know what rules you are breaking and why before you risk throwing away a perfectly good scene for the sake of some experimental framing that may not pay off. Imitation is good, but you are better safe than shoddy!

ABOVE:
This toddler my be very upset at his parent's recent decapitation! Frame your shots carefully.

Colour can affect the "warmth" of a shot and the feeling it conveys to the viewer. Compare the warm reds in a desert (ABOVE) and cold blues and whites in this glacial scene (RIGHT).

SHOOTING

It is odd to think that when creating a film, a visual story, that your visuals are, to a certain extent, subordinate to a separate part of the process, but it is true. Everything you shoot should have the edit in mind.

That is not to say that what you record on tape is just raw material for the editor. Far from it, getting good shots is what camerawork is all about. There are many elements that constitute a good shot and sometimes even an experienced camera operator will forget, in the heat of composition and framing, that one of those elements is editing.

The footage you pass to your editor should not only provide the excellent visuals needed to tell your story, they should also provide the editor with the elements he or she needs to practise their craft artistically. Your script only outlines the plot and dialogue, your storyboard only establishes certain shots. The gaps

missed by the script and storyboard are where the editor works his or her magic with the footage you provide. Watch any scene in a film and you will see that it is composed of numerous shots, from numerous angles, with various cutaways or inserts to cover them. Work out the average shot length for a scene and you will see how many short shots a scene is composed from.

A skilled editor will put this collection of shots together in such a subtle fashion that the audience will not notice them as the scene unfolds. It is your job as camera operator to provide the raw materials for this.

On a simple level, this means that the bundles of tapes you hand over should contain more than just the shots marked out in the storyboard. If you are using expensive film it can be extremely nerve wracking trying to balance the cost against the amount of coverage you think you will need, but this is DV, and it is

LEFT:
Warning: cigarettes can seriously damage your continuity. Drifting smoke and changing cigarette lengths can be the bane of editing.

cheap. If you want to make sure your editor has options then use more tape. As long as you exercise enough self control, do not deluge your editor or force your cast and crew through millions of unnecessary takes, you cannot go wrong. Try to keep in mind three things:

1: Get a master shot. Say you have a conversation that is going to unfold through various two shots of the actors and a selection of cutaways. You could just do the various camera setups needed to capture the elements of the scenes, but this would be very short sighted.

Anything that goes wrong with the lighting, the continuity or the tape could render vital footage unusable. If you have a master take of the whole scene either as a long or medium, depending on how much framing is needed, then your editor always has something to fall back on. If the worst comes to the worst, it is even possible to use the entire master with some generic cutaways. Having a master shot covers your back.

2: Motivation. Your editor is not cutting blindly, randomly deciding to curtail shot 1 here and go to shot 2 there. In general, every shot change needs to have a motivation in order to look natural. We are not necessarily talking about a big dramatic moment or movement, we are talking about a simple thing. Imagine that a character is shown in medium profile and you wish to cut to a close up of his face. You could just get the two shots and let your editor to cut them together, but that would merely be two rather static shots joined together. Instead, try to capture the images up to a point that provides a logical reason to cut from one shot to the next. It could be a simple as a flicker of the eyes, a noise from offscreen or something more elaborate such as the lighting of a cigarette. In any case you need some moment that will not overpower the content of the shot, but will be noticeable enough to provide a reason to cut.

3: Advancement. Advancement is simple. In the same way that each scene of your film advances the plot or adds subtle shadings to characterization, each shot should offer the same advancement to the scene it is contained within. You are not simply adding shots in order to keep the scene from being static and boring, you are adding them in order to enhance the scene itself. If you have a character smoking a cigarette, are they taking deep satisfying drags or short, quick nervous ones? Do they neatly tap their ash into the ashtray or are they insolently staining the carpet? You do not want to use shots so blatantly that they telegraph their meaning, but at the same time think about the way in which each shot is telling the miniature story of that scene. Think how the person in shot is to be portrayed and make sure that the shots you take capture the essence of this so that your editor can visually build the scene from a natural start to a natural finish in accordance with the overt meanings of the screenplay.

SHOT TYPES

As a film/documentary maker you are already a visual person and can see pictures in your head of how you want things to look. You will have used these pictures to create your storyboard and amend your script. This is all very well when you are merely clarifying things for yourself, but sooner or later you have to explain what you want to the crew, so it is important to get an idea of the definitions of the shots and the forms they take so that you are not saying: "Two guys head to head, we cannot see below

The distance and framing of a shot can be the difference between an image that sets a scene, such as those on the far left, and an image that provides important detail, such as those on the near left.

their necks, but their faces are really angry and we are over here not over there" when what you actually want to be saying is: "A big close up profile two shot."

There are various terms used to describe the type, angle and content of the shot and you can combine them in any number of ways, for example H/A XLS, which would be a high angle extra long shot. Terms can also be combined with movements of your pan and tilt head or dolly. Below is an outline of the most commonly used shot types, their meaning and their abbreviations used in shot planning, storyboard and shooting script. We will assume, for the sake of simplicity, that the subject of all these shots is a person and that the compositional rules for head and foot room have been properly taken into account.

Extreme Long Shot (ELS): The person is so far in the distance that they are only just recognizable as a figure, with no discernible detail.

Very Long Shot (VLS): The subject is now close enough to take up approximately half the height of the screen from head to toe. You can probably make out a few more details such as clothes and gender and maybe, if the subject is familiar, identity.

Long Shot (LS): From head to toe the person now takes up almost the full height of the screen with the exception of the head and foot room that is left available as part of the composition.

Medium Long Shot (MLS): The subject is now framed so that they are cut off just below the knees. They are recognizable and their activities are discernible.

Medium Shot (MS): Now framed from just below the waist upward, the person is close enough to fully convey moods and the fine details of activity without having to "play to the balcony".

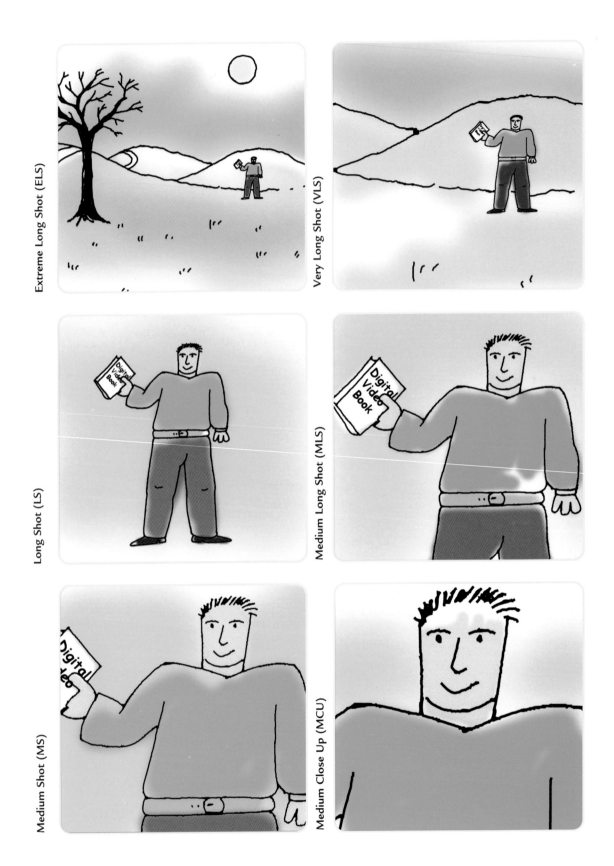

Extreme Long Shot (ELS)

Very Long Shot (VLS)

Long Shot (LS)

Medium Long Shot (MLS)

Medium Shot (MS)

Medium Close Up (MCU)

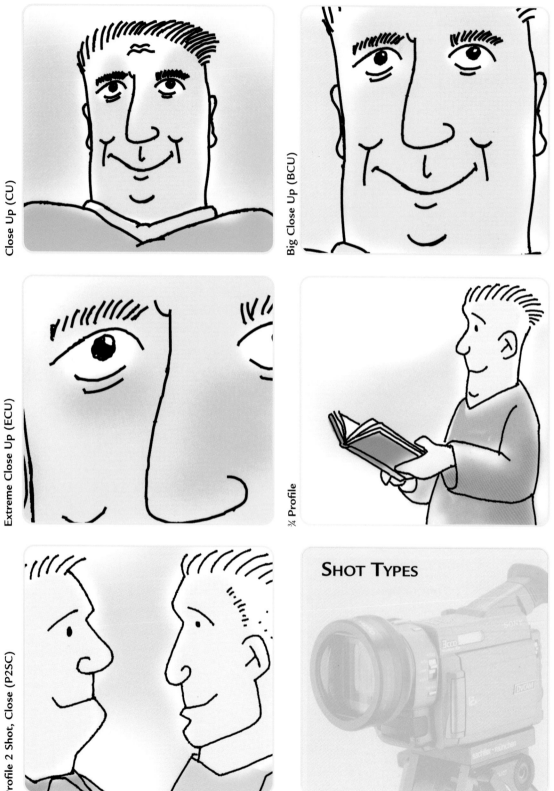

Close Up (CU)

Big Close Up (BCU)

Extreme Close Up (ECU)

¾ Profile

Profile 2 Shot, Close (P2SC)

SHOT TYPES

Medium Close Up (MCU): Framed from the chest up, the actions carried out by the character are most likely lost out of shot, but their expression is fully readable and they have begun to dominate the shot.

Close Up (CU): Framed from the tops of the shoulder upwards, the audience is now on very intimate terms with the subject, picking up a massive range of facial expression and possibly feeling intimidated, attracted etc, according to the portrayal of the character.

Big Close Up (BCU): The subject is now totally dominating the screen, framed from chin to hairline. Simple movements and expressions now begin to seem exaggerated and the effect is good for conveying powerful emotions.

Extreme Close Up (ECU): Now framed from just below the nose to just above the eyebrows. This shot should only be used in carefully selected circumstances as the slightest flicker of the eyes is incredibly exaggerated. Can powerfully convey emotions or simple dominance of surroundings, but is equally likely to descend into unwanted parody.

Profile: This is a shot taken from the side of the subject rather than head on.

¾ Profile: This a very naturalistic shot taken from a point approximately three-quarters of the way around the 90 degree angle between head on and profile. Especially useful for conveying depth or creating the impression that the subject is paying attention to something unseen offscreen.

The Two Shot (2S): This implies that there are two people in the frame and is used in three different ways. The most common is the over-the-shoulder-2s which is used in conversation, usually with a roughly three-quarter profile to take in the back and side of the nearer person facing away from the cam with the other person next to them but further away. The other variations are the profile two shot, which features the two people

directly facing each other, and the camera off at the side capturing a profile. Remember not to cross the line when using this. Finally there is the to-camera-two-shot, used if you have to people speaking directly to camera placed side by side and shot head on. Remember that variations in height and... ahem... weight can make these types of shots look comedic if composed improperly. If all else fails, bite the bullet and get the shorter person to stand on a box.

Lastly you have your multitude of camera angles, all of which can essentially be reduced to variations of extremity on the following:

High Angle (H/A): Looking down from just above head height.

Low Angle (L/A): Looking up from just below shoulder height.

Bird's Eye: Looking straight down from above.

Worm's Eye: Looking up from floor level.

You do not really need to quote an angle if the shot takes place at a level approximating that which you get from your own eyeballs, but it is worth remembering subtle variations such as **Point Of View** (POV) shots, which are from a normal height, but generally include movement and rhythm to create the illusion that they are views from a character's eye rather than the camera, and fly-on-the-wall, which is really a term for an overall style, but is occasionally used to imply a high angle wide shot from just below ceiling level.

Profile 2 shots can be used to show people in their surroundings (ABOVE) or, conversely, isolate them (LEFT).

The movies *Se7en* (1995, RIGHT), *Vanilla Sky* (2001, BELOW), and *Black Narcissus* (1947, BELOW RIGHT), all make dramatic and innovative use of lighting.

LIGHTING

It is so easy to forget, amid all the technical innovation of digital, that light is one of a video-maker's most powerful tools. Used with care and consideration it can raise the quality of a video production.

Light alters an audience's perception of a scene, whether that be in a fiction video, documentary or an interview situation. Even in holiday or wedding videos, light can be used to suggest different moods and feelings.

Learning about light and lighting is worth a book in itself. That is why any self-respecting TV or film features a lighting cameraman in its credits, whose sole job it is to create the mood and lighting effects the director wants.

On large productions you will often see the term **Director of Photography** (DoP) or **Cinematographer**; these are creative people who work with a director to shape the way a film or TV show looks. The best way to understand what a DoP does is to turn yourself into a part-time Media Studies student and just watch lots of movies and videos!

There are many famous DoPs and Cinematographers, among them Jack Cardiff (*Black Narcissus*), Darius Khondji (*Se7en*), Roger Deakins (Coen Brothers movies including *The Man Who Wasn't There* and *Fargo*) and John Toll (*The Thin Red Line, Vanilla Sky*) who paint with light to help ensure the movies retain their silver screen magic. However, they also help

push the boundaries of what we see on film, as working with special effects teams they can create highly stylised environments for films such as *Blade Runner* or *Moulin Rouge*, or even *Saving Private Ryan* (where cinematographer Janusz Kaminski removed the protective coating

from the camera lens to help provide a bleached out, more realistic look for the film).

Lighting is not only the preserve of these masters of the art; lighting design can be achieved on the most modest of budgets and by the least experienced videomaker. What follows is a little taster of how…

LIGHT SOURCES

As mentioned earlier in this book, there are only two forms of light source – natural and artificial. However, there are a myriad of choices for lighting within these two forms and getting the right one, or the correct blend of lighting, is where the skill part (or you could call it trial and error) comes in.

To achieve a realistic, well-balanced lighting design for your video, you first need to ensure your digital camcorder knows what colour light actually is, in order for it to assume that light is white. You do this by setting the white balance – sadly, for those of you without this feature on your DV camcorder, you will have to rely on the auto white balance system.

A knowledge of colour temperature is also handy when you are working with light, as you

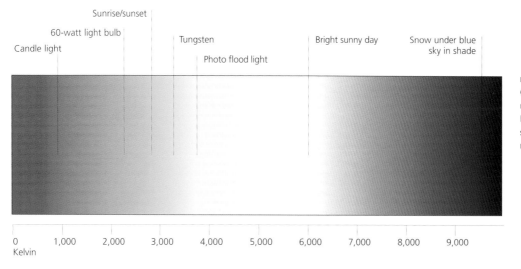

Sunrise/sunset

60-watt light bulb

Tungsten

Bright sunny day

Snow under blue sky in shade

Candle light

Photo flood light

| 0 | 1,000 | 2,000 | 3,000 | 4,000 | 5,000 | 6,000 | 7,000 | 8,000 | 9,000 |

Kelvin

There are only two light sources: natural and artificial. Difficulties for videomakers occur when the two are mixed.

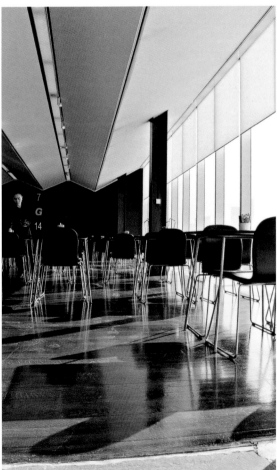

will discover there is a natural order to the sources we use. Colour temperature is measured in degrees Kelvin (°K), and to give you an idea, a candle is measured at around 1,900°K, a light bulb at 2,500°K, normal daylight at 5,500°K and a bright sunlit sky at 10,000°K. Unfortunately for videomakers these sources do not keep to themselves and will often appear together within your camcorder's viewfinder, causing you production problems. Mixed lighting, as it is known, is apparent when you stand by a window in the office, while the office lighting is on. Therefore the "blue" state of natural light is being mixed with the orange/red of artificial light. Depending on how you have the camcorder's white balance set up, you will get a mixture of accurate and inaccurate colours. Having it set up for daylight will leave the outside light correctly balanced, but will leave the interior shots with over-saturated colours in the orange/red spectrum. Set up for indoor light, and though the office will be balanced correctly, any sign of the outside world will have a distinctly blue cast. Your options for relief here involve filter sheets. You can either cover the window with orange/red filtering sheets and balance the camcorder for artificial light, or perhaps choose to cover the artificial lights with a blue filter and go for a daylight white balance on your camcorder.

While colour temperature is measured in °K, and light output is measured in lumens, illumination is measured in lux. Another glance at your digital camcorder manual will highlight the minimum lux (illumination) figure your model will operate at. This is only a guide figure; be warned, the lower the illumination the more grain (noise) you will see on the picture – and hence one of the main reasons to use lighting.

One lux is actually the amount of light falling on an area, one metre square, one metre from

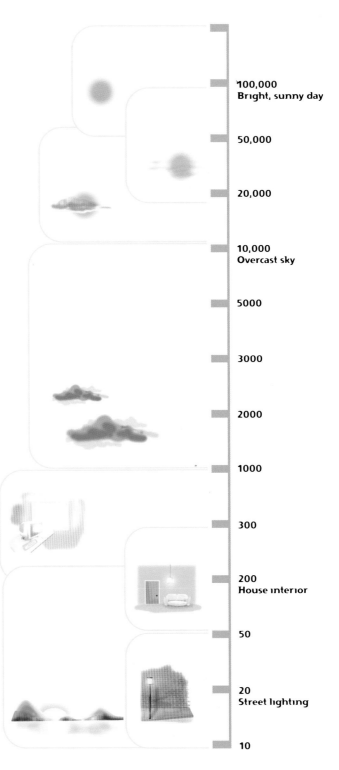

LUX LEVEL CHART

	
100,000	Bright, sunny day
50,000	
20,000	
10,000	Overcast sky
5000	
3000	
2000	
1000	
300	
200	House interior
50	
20	Street lighting
10	

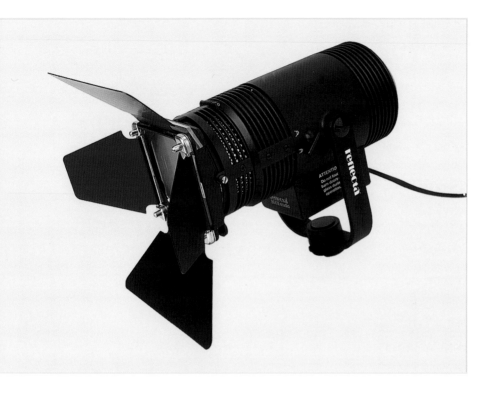

corder's own battery pack. Either way these lights provide little flexibility and their output is harsh and lacks directionality.

Much better are the second and third options. Handheld lights are far more powerful, can be run from the mains or a battery system, and can be positioned wherever they are needed. Provided, of course, that you have an extra crew member on hand to hold them!

Stand mounted lights are invariably available in packs: a selection of two or three lights is offered, stands are included, and you might also get a diffuser or reflector for your troubles as well. Very similar to the lights used in professional productions, stand-mounted lights use mains power and offer the most versatility in lighting designs.

Within these second and third categories of lights we will find a diverse selection of illumination to cover all the most obvious lighting scenarios.

the source of one lumen. In practice, the inside of a house is no more than 200 lux, an overcast sky no more than 10,000 lux, while a bright sunny day will register at around 100,000 lux.

TYPES OF LIGHT

So far we have only dealt with light sources around us, daylight and the artificial lights that surround us, office and home lights, street lights etc. The whole shooting match only gets more complicated as the videomaker introduces his or her own lighting system. Film and TV productions will usually employ a sophisticated array of lights, or **luminaires** as they are sometimes known, while the amateur videomaker realistically has three choices of light: on-camcorder; handheld; or stand mounted.

On-camcorder lights can either be built-in to the camcorder or attached via an accessory shoe. Power is supplied by a battery (in some cases) which fits into the light, or from the cam-

FLOODLIGHT, SPOTLIGHT AND SOFT LIGHTS

Two terms have been devised to describe the width of the beam provided by lights: floodlight and spotlight. The first provides a wider angle, sometimes up to 90°, but generally around 60°. Spotlight is a far narrower beam, typically being around 20 to 30°.

In looking at these two terms, it is important to know the role that distance plays with light. Floodlights are usually placed closer to the subject

or area, because light intensity diminishes with distance. Spotlights, due to their narrower beam, can direct light over a greater distance.

By far the most common light is the focusing reflector, though you will more normally hear it referred to as a **redhead**. Redheads are powerful lights that can be used both as floodlights and spotlights, courtesy of their directional beam. Even with its capacity as a floodlight, the redhead is often used as a key light, the main ingredient in any set-up, as it provides shape and texture. This is to allow another type, a softlight, to be used. Softlights provide an overall level of light for a scene and also help to fill-in the shadows which are created by floodlights and spotlights.

Other specific types of light used in more professional situations, typically a studio set-up, include beam, sealed-beam and cyc lights.

SINGLE POINT LIGHTING

For many amateur productions this is going to be the "norm" situation. Simply using one light to lift the gloom and illuminate the subject/subjects. However, do not be fooled into thinking there is not any flexibility in this scenario because there is.

It has often been suggested that an ideal starting point for this system is for us to imagine where the light in the scene is coming from. Depending on what you are shooting, try and establish from where natural or artificial light would shine onto your subject. You have options here: it could come from above, or to the side of the subject, or it could even come from directly in front of them. What you have to decide is whether the shadows cast by the light look right or wrong. Study your subject, if you have a

LIGHTING

LEFT: **Two-point lighting: This will achieve a natural look.**

BELOW:
Two examples of single point lighting with the main light source coming from a different angle, one behind the camera, and one to the left.

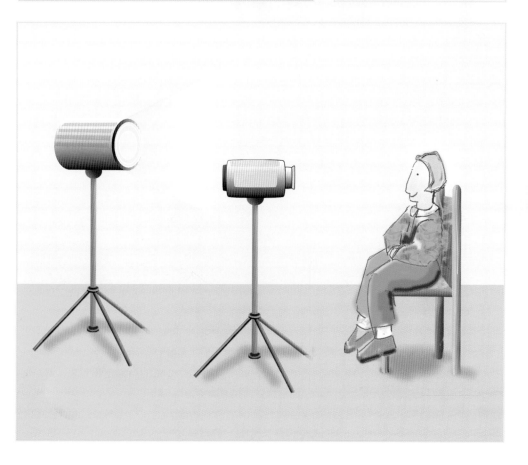

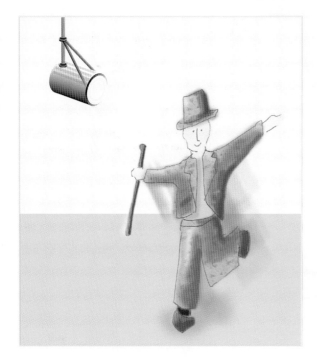

ABOVE:
Three point lighting.

LEFT AND BELOW:
Placing your main light
source at different heights
reduces or increases
the length of shadows.

monitor hooked up, look at it. Do you want the shadows to appear where they are? Feel free to move the light around, and if you have the capability, vary the beam to give less harsh shadows.

In lighting design the terms **hard light** and **soft light** are used to make the distinction between different types of shadow. If you can think that sunshine provides a harsh, abrasive light with very defined shadows, while a cloudy sky will provide shadows which are softer and more diffused. Decide which of the two suits your video the best and implement that one.

Two Point Lighting

With a second lamp in your set-up you do not have to pay as much attention to the harsh shadows that might be created by a single point shoot. Your first light can now be positioned to provide a hard light, or as it is now referred to, your **key light** and is adding both shape and texture. This new second light is known as a **fill light** and is now providing a softer tone to the scene.

With the key light only, the camcorder will not be able to make out any detail from the shaded parts of our scene, but once we have added the fill light, these areas will become illuminated. However, because fill light is soft light, we will not be contradicting the shadow thrown by the key light.

Although lighting has very few set rules, and precious little right or wrong approaches – this is art we are talking about here, if it works for you, then it is the right thing to do – it is generally accepted that a fill light will be placed on the opposite side to the key light.

Three Point Lighting

Making your lighting set-up a trio, means finding another name for this new light, and that is **back light**. It is placed behind the subject, and shines towards the camcorder, in

order that your subject stands out from the background. This is especially important if your subject is wearing dark colours against a dark background, as camcorders do not distinguish between shades of black!

It is possible to use either a hard or soft light, as a backlight as you should not see the shadows it creates.

ACCESSORIES

In their professional capacity, a lighting camera-man/woman will have a massive bag of tricks for subtly shading and emphasizing light. With all the accessories and apparel a videomaker already has, it is unlikely you will be able to match them. However, it is worth knowing a few bits and pieces.

BARN DOORS

A frame of four metal flaps which fit around a light, barn doors can be fitted to spotlights or floodlights to restrict the beam size.

GELS AND FILTERS

Just like digital camcorders, lights can use filters

to change their colour. There is a wide range of coloured gels, as they are called, which come in rolls and are cut to fit into a frame that slots in front of the light. It is possible to get them in solid colours, or for more subtle shading and texture, pastel and graduated gels are available.

SCRIMS

A screen placed in front of the light to reduce its intensity, but without altering its colour temperature.

SNOOTS

These are like barn doors, only conical in shape rather than square. Snoots are only usually fitted to spotlights so that they can restrict the diameter of the beam. Snoots are available in a range of sizes, and allow the user to shine small circles of light toward a subject to highlight certain areas.

Learn a few basic rules about light and shadow and you will be able to achieve the desired result whatever the scene you are shooting.

4

Production Time

Production Time

PUTTING A CREW TOGETHER

Ask any TV or production company what digital technology has done for them, and you will get a mixed response. While digital video has liberated videomakers to a point where the number of people needed to make a production can sometimes be just one, this naturally has caused "downsizing" within the media industry. News crews reporting on location can often consist of a cameraman and a reporter, or in some cases just a reporter who operates the camera by remote.

For videomakers this set of circumstances shows the power of digital videomaking over its analogue past, as it has reduced the division between "them and us", between the pros and the amateurs. Digital Video has also redefined the term **broadcast quality**. Having an entire production crew milling around a location, especially with documentaries and reality TV shows, often diminishes the responses of the protagonists. In fact, it is possible to record people even with the smallest digital camcorders without them registering that they are being recorded. Digital Video is good enough to be seen on TV (and increasingly cinema) screens, and now what matters most is the content and the context of the programme.

The image and sound quality of DV is as high as its ease of use factor. And, with the affordability of computer-based editing it is possible to complete the picture by cutting your video, and then distributing it on digital video tape, VHS, DVD, Video CD or via the Internet.

Not surprisingly, this has caused many videomakers to turn into one man bands, working on their own to produce a variety of video content. However, to think that you have to work "on your tod" as a digital videomaker is missing both the point and the benefit of working with a crew. As we have mentioned, context is everything and if you are planning to shoot any complicated production, such as a fiction film (heck, even if you are shooting a wedding) it is nice to have someone checking you are actually

RIGHT:
The boom in reality television is due, at least in part, to the quality of modern digital video camcorders.

recording the sound while you are concentrating on the visuals. However, crew members can also be a contradiction, so remember that while it is helpful to have extra eyes, ears and hands, it is also other people to manage … and feed! Try to tailor the number of crew you need to the scale of the production. Crew members do not have to do just one job.

YOU'RE THE BOSS

Since you are the one reading this book, we are going to assume that you are the head honcho, top banana, so to speak, and it is your little baby we are filming. You become the director and, unless you really want someone else to do the lens work, you are the camera operator as well. It is easy to get caught up with just the images, so you want a member of crew to look after sound. OK, meet your sound recordist. It is their job to monitor the sound levels, to check that the sound is not booming away from the microphone and distorting the audio. They need to ensure that dialogue is recorded cleanly, because it is unlikely on an amateur production that you will get a shot at dialogue replacement – even with the sophistication of computer editing. You can simply allocate the sound recordist a set of headphones, plug them into the camcorder, and ask them to check the sound, or you can double up, and, if you are using a microphone on a boom, ask them to hold the boom. This ensures they are more involved and can actually have an effect on the sound being laid down.

Next up, and getting a little more professional here, we have the lighting technician (or assistant). As you might have seen in the previous chapter, lighting can be a complicated business and a lighting tech can lift that burden from you. They will be in charge of positioning

LEFT:
It helps to ensure that all you need is in place before you start to shoot a scene.

the lights as well as suggesting what gels it might be useful to use. A lighting tech also has a responsibility for safety. Lights can get very, very hot, and also have an alarming tendency to explode, and no inexperienced crew members should be allowed to move or touch them without the lighting tech's say-so.

Continuity might sound like a luxury from a film set, but it is a useful function and if performed correctly can save you having to re-shoot scenes, or entire sequences. Essentially, continuity ensures an actor is wearing the correct clothes for each shot, that their hairstyle has not changed, that their make-up remains consistent and that the cigarette they are smoking in the scene does not get longer and shorter as you do new takes or shots! With so much going on it is easy to forget that your lead actor was wearing jeans in the scene you shot yesterday, but today is wearing suit trousers. The two scenes, shot on separate days, can easily be meant to be next to each other in your edit. Little things like cigarettes, or the eating of food

might cause nightmares in post production as you spot the differences in scenes. Continuity should also check the actors are speaking the right parts of dialogue and can prevent you from "crossing the line" by shooting a sequence from the wrong side.

For some of your crew you will have to be creative in supplying titles. Production Assistant sounds so much more professional than gopher, though essentially that is what this role is. You might want them to use the clapperboard – they will like that – but they are also useful for supplying sustenance. Having a crew means having

to feed people, and good work does not often come from a malnourished crew. You will probably be working long hours and you want everyone with you, not against you.

For the bigger, and finer, things in life you might want to employ a Producer. Although in most low-budget DV productions the "video-maker" would probably take this role, if you can find someone to produce, it can free the "artist" in you to concentrate purely on the creative side. A Producer ensures budgets are met, assuming that there is a budget to start with. They can liaise with other crew members and can diffuse tricky situations, can smooth the use of a location with "the authorities" whilst also being on hand at a later date to take some of the credit for your successful production!

CREW CHECKLIST

Meet your crew, and find out what they do!

Producer: often "The Big Cheese" but, more appropriately on low-budget produc-tions, finds cash, actors, food, equipment and solves problems.

Director: shouts "Action!", bosses everyone around. Remember, it is their vision you are re-creating.

Camcorder Operator: helps set up shots, tells Director if take is a good one, provides vision.

Sound Recordist/Monitor: checks sound levels and quality of recorded sound, wears headphones, can be deafened very easily.

Lighting Assistant: helps create mood of video with lighting design, turns on and positions lights!

Continuity: checks if you are crossing the line, ensures actors are wearing the right apparel and speaking the right lines, location is free from period clashes, takes photos.

Production Assistant: real title = gopher; gets tape, batteries and tea, on occasion gets to hold clapperboard.

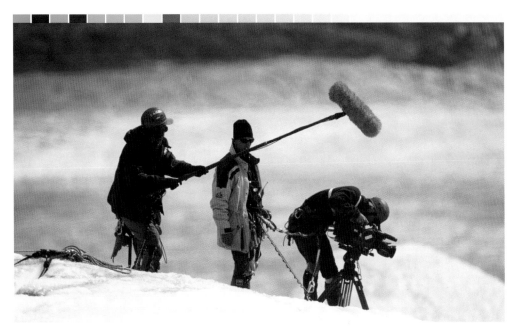

LEFT:
Being prepared for the filming location is vital.

PLAN AHEAD

Embarking on a shoot is a risky business. It is the point in your production when you become irrevocably committed to spending serious money and time on your video, and you do not want things to start going wrong. You need to have dealt with every possible problem before going on a shoot, because once you are kitted up and on location, or in a studio, you are spending money every second you are there and do not want to be wasting time on anything that is not vital.

Sorting out a checklist before starting the shoot is the best way of avoiding time consuming mistakes, and it also helps you decide which people you can delegate jobs to. Equipment, for example, should be the priority of its respective departments. Camera operators and sound crews should know that they are expected to provide batteries, tapes, DATs etc, albeit at your expense. Production assistants or runners should be dealing with the elements of the shoot that are there to keep people happy and safe, as opposed to ending up on screen: food, first aid kits, etc.

Before you delegate anything, however, you need to be aware of what tasks and requirements you have, as well as working out things that are necessary for the shoot. Below is a selection of common pitfalls and handy hints that will help things go smoothly.

Make sure you have permission to shoot in your particular locations and make sure it is not just permission from some chap who happened to be passing through at the time. If you are shooting at a factory, for example, it may not be enough simply to have permission from the owner. The shift manager may have concerns about the potential workflow disruption you may cause; the security staff may be worried about having so many strangers on site; the health and safety officer may not be keen on having cables gaffer-taped all over the place. All these people can throw a perfectly justifiable

RIGHT:
Shooting on location is great, but make sure you are safe, legal and well prepared.

spanner in the works. If you cannot get in touch with all of them, at least make sure that whoever you have spoken to has checked things with them and get copies of your permission in writing to prove you are allowed to shoot where you say you are.

When doing your reconnoître do not just be thinking about the actual composition of your shots, make sure you keep an eye out for practical details as well. Are the power points conveniently located and suitable for your equipment or will you be running cables all over the place? If so, take gaffer tape to secure cables to the floor. (In fact, take gaffer tape everywhere, it is incredibly useful stuff.) Is there any annoying background noise that will mess up your soundtrack? Are certain areas particularly busy and likely to pose continuity problems? Forewarned is forearmed.

Think about your shooting ratio and adjust it according to specific situations. There is no point planning a 6:1 ratio (six minutes of shooting for every minute that reaches the screen) for easily controllable studio shots, and you definitely do not want to allow yourself a 3:1 ratio for a location shoot where any number of unscheduled occurrences can take you over the number of tapes you had planned to shoot. This is a digital video, its cheap, so burn tape as much as you like when in the field and make up for any extravagances by being more conservative with your safer shots – inserts, studio shoots, etc.

Plan your shots and setups carefully. Never be chronological with your shooting order and setups unless that is the most practical method, which it rarely is. If scene one is in a dining room, scene two in a bedroom and scene three back in the dining room, then film scenes one and three back-to-back before moving all your kit. Similarly, if a scene is composed of several

LEFT: TOP TO BOTTOM
Stately homes and railway stations will have safety and security concerns, and you should show consideration whenever you are shooting in public.

shots from different angles, take the similarly angled shots back-to-back rather than constantly lugging tripods and camcorders backwards and forwards across the set.

Draw a storyboard from your script that shows the action as it will be onscreen, then draw a bird's eye diagram of each set or location and mark out where you will need to set up to get the shots on your storyboard. Then go through the script, with the diagram to hand, noting scene and shot numbers next to their respective shot locations until you have clusters of numbers scattered around your diagram. This way you can break the whole thing down into fewer repeated setups and also check to make sure you will not be crossing the line with certain shots.

If you are doing this, you will find that the contents of your DV tapes are hopelessly garbled and in totally the wrong order, but that is OK, clapperboards are for more than just synchronizing sound. If you are recording a separate, off camera soundtrack (and we hope you are – it gives much better results) then you will already have a clapperboard that will allow you to sync the audio from mini disc or DAT to the video. On this clapper board, log the scene, shot and take number and when it comes to editing time, you will find that your unsequential recordings are no more inconvenient to work with than those shot in linear fashion.

Having worked out your shot list, move on to a call list. If you are shooting scenes 2, 8 and 15, for example, at a certain location on a

RIGHT:
A setup diagram help you plan your camera moves before any tape is wasted.

Shots: 1, 3

4, 6

2,7

Desk

5

Bookshelf

certain day, then make sure everyone who needs to be there will be and no one who need not be there ends up wasting a day on site. List the scenes, the locations and addresses, the cast and crew members required to be there, the equipment needed (there is no point dragging 20 feet of dolly track to a location that will only feature in static shots), etc. Distribute this list to all cast and crew and make sure they know when and where they are supposed to be and how to get there. Add an appendix to this list showing alternate locations for certain days in case it rains at one of your external locations and you want to avoid downtime by substituting an alternative.

When timetabling your shoot consult with those in the know. If your gaffer says it will take two hours to set up the lights for a specific shot then there is no point planning to finish that shot and move on in one hour. Remember to schedule in a little leeway for errors, consultations, discussions and suchlike (but not too much leeway – you have to stay in control of the time and money being spent on the shoot).

Another thing to allow for in the schedule are last-minute onset rehearsals, be it for nervous interview subjects or amnesiac actors. Again, be careful how much time you allow. An over rehearsed interview subject will come across as being too practised and boring, and an actor can lose the vibrant edge of their per-formance if they have been through it too many times. Equally, do not be to stingy with rehearsal times – no one should have to appear on camera if they feel totally uncomfortable doing so. It is a question of getting to know your people and figuring out when they need the practice and when they are just nervously procrastinating.

Remember to allocate time for lunch. Most of your cast and crew are probably working cheap or for free and it is not a lot to ask that they at least be fed. Even if your budget is too tight to run to onsite catering, make (or get the runner to make) a couple of big flasks of tea and coffee and a selection of sandwiches and snacks.

Lastly, bring cash and cheque books. You may think you have everything you need, but you never know when you will need to improvise. On one shoot, several years ago, we had the embarrassing experience of having to use all our petty cash to bribe away local urchins – too young to be given a fat lip, but old enough to carry out their threats of pinching a few cameras. The only solution, in this particular case, was bribery, which worked a treat.

We are not suggesting that you specifically budget for backhanders, but it illustrates the point that you never know what might crop up during a shoot.

Act like a boy scout – be prepared.

5

Shooting Situations

Shooting Situations

T here are a million and one reasons why you'll find yourself pressing the big red record button but of those, the main situations are likely to be: fiction, documentary, interviews, weddings and holidays. Many of the same shooting principles apply to these scenarios but there are techniques within each discipline which are useful to know.

Everyone armed with a camcorder can make holiday videos, because it's the easiest form of videomaking – virtually everyone takes at least one holiday a year and it ostensibly requires you just to point and shoot – to record your holiday memories. However, if you want to get the best out of digital video then every time you press the record button you need to have thought about what and how you are shooting. Even if you just want to make a record of your holiday, giving some consideration to the images you take will ensure you have a video more than one or two of you will want to watch!

FICTION FINDING

We thought we'd start with the most ambitious project videomakers can tackle – the fiction video. This can be in short form (under 15–20 minutes) or a full-on feature-length production, but the same basic rules apply.

You might ask, "Why would I want to make a fiction video? surely my digital camcorder's just for recording the odd event?" They are good questions. The answers are that by dealing in fiction you are doing something different and having to think about video in a multitude of ways. It will involve working with actors, directing action, working with a script – and perhaps best of all means you can shout "Action!" ... and mean it.

GETTING PREPARED

If you decide to embark on shooting a fiction video you will need to be organized. So where to start? Well as we've looked at scripting and storyboards in a previous chapters we'll head there first. Before you shoot a single sequence

you need to have an idea, and then you need to have a story. You then need to map out what you need to shoot this story, in terms of equipment, crew and actors. It's simply no use starting a project without a list of everything you are going to use.

Questions you need to ask are:

• Do I need more than one camcorder? A second camcorder gives you options for recording the same scene from different angles which might prove useful when editing. You also need to consider what accessories you will need: tripod, micro- phone, headphones, tapes, batteries, charger, rainjacket/camcorder protection?

• How many crew members do I need, and where can I get them?

• Do I want trained actors or will my friends do it for a laugh? Tricky one this as your friends might not be able to act, might not be capable of meeting your demands, and might not be your friends after the shoot!

• Will I need lighting? If you do then what sort: on camera, handheld or stand mounted?

• Which locations will I be using? And have I got permission to film there?

• What costumes and props do I need? Where will I get them, and, if this is a period piece what do I need to remember to remove from view? Digital watches, television aerials, cars and planes were not that evident in Victorian Britain!

• How will I shoot any action sequences I want? And who will be doing the stunts?

Answering these questions will give you an insight into how complicated (or not) your production is going to be.

LEFT:
Using more than one camcorder will help you to cover action scenes comprehensively, as in 1955's *Rebel Without a Cause*.

Don't Lose the Plot

Once you've assembled your equipment, script and actors it's best to embark on a period of rehearsal. Doing this enables the actors to familiarize themselves with the character they are playing. Hopefully they will have done some research into how they (or you) want them to play the role, but you could also ask them to think of a "back story" for the person they are playing. This is information not in the script, and not necessarily relating to the story, but it enables the actors to understand where their character comes from, and why they react the way they do to certain situations. It can include where they come from, what their family background is, what jobs they have done and what relationships they have had. In acting terms this is often known as the method approach, and while many actors simply want to turn up and say their lines, it's useful encouraging them to think just a little about the person they are playing.

Rehearsal also helps actors familiarize themselves with their lines. This might seem a little trite, but it's surprising how many performers turn up on location barely on nodding terms with what they are supposed to say. If you choose to use your friends in your video then this might easily be the case. There is a way around the problem of not knowing your lines – and no we don't mean firing the actor – and it's known as an idiot board. You simply write down the lines in big text on a piece of card and have someone hold the card out of sight of the camcorder but close enough for the actors to refer to!

The low cost of digital tape, and the unobtrusive design of digital camcorders should also allow you to record the rehearsals. This will give you an opportunity to see if the dialogue that's been written works, and sounds realistic, when

RIGHT:
Professional touches, using a clapperboard and numbering your scenes and takes, will help in post-production.

spoken. It also gives videomakers the opportunity to block out sequence, such as where an actor stands and then moves to, within a scene, along with giving the videomaker a chance to try out different shot angles.

With rehearsal over, and any adjustments to the scripts and storyboards made, it's time to move to the "in production" stage of your video. You should have a shot list ready along with your shooting schedule. You should have checked the actors and crew can make the times you've stipulated. Try to ensure you don't have to zip back and forth between locations, shooting scenes out of sequence but which need to be shot in the same location, and try to be realistic about how many scenes and how much footage you can shoot each day. Professional productions often have very long shooting days, often from 5.00 am to after 9.00 or 10.00 pm, but if you are not paying your crew or actors, or even if you're

using your friends try not to subject them to Kubrick and Hitchcock-esque demands. Get to a location early, and along with your crew set up so that everything is prepared before the actors arrive. Check sound levels, light levels and make sure you're not getting in anybody's way, and most important of all, definitely, most absolutely, make sure everyone involved in the production gets some food.

RECORDING CONTRACT

One of the real secrets to success in making a fiction video is to think ahead. When you're shooting you should also be thinking about editing. So, don't just yell, "Action!" and start recording. Take a few tips from the professionals, it will mean recording more footage than you'll use but will cut down the amount of time spent in the edit suite, while also ensuring you don't go prematurely grey or lose your hair! In film pro-

ABOVE:
Fight scenes need to be choreographed to look realistic and to protect your cast.

duction, cameras take time to come up to speed, starting the action before the camera achieves "speed" could mean you don't get the shot you want. This is a good policy to adopt. Start the camcorder recording, the director shouts "Rolling!", get the clapperboard holder to mark the scene (calling out, "Scene one, Take one," etc), then shout, "Action!", have someone count down – five, four, three, two, one – using their fingers to indicate to the actors. Five to three should be spoken as well, to give the sound recordist an idea of sound levels, while two and

one should be silent and indicated by fingers only. Each scene should be allowed to overrun for around five seconds before the Director calls, "Cut!" Using this checklist you not only know what scene and take you've recorded and are looking at when in the edit suite, but also you provide correct sound levels and give the actors the opportunity to do something unexpected at the end of a scene, that you might want to keep.

At the end of a day's shooting try to look at what you've recorded. In film speak these are known as rushes. Digital video has an advantage

RIGHT:
Action scenes are the centrepiece of many movies, but they can seriously damage the budget if something went badly wrong.

LEFT:
Get permission before shooting in busy locations. Tom Cruise and director Cameron Crowe needed to for *Vanilla Sky* (2001).

even just be shooting a sequence in a quiet park, yet you can still intrude on the public.

Action sequences serve several purposes, they make your video more dramatic, increase its tension, atmosphere and pace. The secret here is coverage. In a film or video events don't have to take place in real time – a 10-minute race doesn't need 10 minutes on screen. A mixture of shots will serve your purpose better and make it easier for you to edit a sequence together. Change camera positions regularly, and make sure each shot is significantly different to the previous one. A good tip is to change shot size, starting with a master shot to establish the situation and then move from mid range shots to close ups and occasionally back to a master shot so the viewer doesn't lose track of what is going on.

Professional productions will employ a stunt man or stunt team to carry out the complicated action sequences, but it's unlikely a low budget amateur production will be able to afford their services. The safety of your entire crew should be paramount so any action sequences should be well choreographed and rehearsed. Again, the range of camera angles can provide the dynamics for you.

Car chases are going to be pretty much out of the question on low budget videos because of the danger involved, but they are possible if you have permission to film in deserted locations well away from main roads and thoroughfares. Accessories manufacturers have a selection of car clamps and suction mounts that will allow you to fasten your (very expensive) digital camcorder to a vehicle, allowing you to get fast moving action, as well as close ups and interior shots.

over film here, in that film has to be processed before the rushes can be viewed, but digital video footage can be viewed immediately. If you want, a scene can be checked as soon as it has been recorded.

ACTION STATIONS

Finally it's worth mentioning action sequences. Even the most pedestrian of stories will require action at some point. It could just be a character running down the street, or falling to the ground after a punch-up. Be wary of anything that could go wrong and injure the actor, the crew or anybody on or near the location. This is especially pertinent if you've adopted the guerilla video-making tactic of not gaining permission to shoot on location, and simply turn up and try to get everything on tape before you're moved on. Imagine you decide to get some shots of a character running down London's Oxford Street. The number of people affected by your presence could run into thousands. Be careful. You could

INTERVIEWS

In the commercial world, the interview is probably the most common set-up a jobbing camera operator is likely to experience. It doesn't matter if it's a current affairs show, documentary for broadcast, an image film, or product demo. The chances are that somewhere you'll have a talking head. As an amateur, an interview can convey information "straight from the horse's mouth", and is sometimes the only way to explain a subject without resorting to expensive travel, graphics or stock footage. Interviews fall into two categories, single camera and multi-camera shoots.

Let's start with the most basic, single camera interview. It is possible to conduct the interview, operate the camera and adjust the sound all at the same time, but something will be lacking. I guarantee it. Either the technical side will be less than perfect or the subject will notice that they're not getting your full and undivided attention and will not perform their best in front of the camera. Make no mistake, what you're doing here is recording a performance, albeit an unscripted one and your "talent" needs as much attention as the most demanding actor. If you're the director then sit down in position and talk to the interviewee whilst the camera operator sets the lights and the sound recordist fumbles with cables and microphones. If you're the camera person then give the interviewee a warning before zapping them with 800 watts of light. Oh and don't say "I'm going to switch this

RIGHT:
The "standard portrait"
lighting set up is
the basis of nearly
every situation.

LEFT:
An example of the "over-the-shoulder 2 shot".

what the camera chip sees, not what levels the tape records and there can be quite a difference between the two. A good light meter will dispel any doubts you might have and make you look like you really know what you're doing.

A couple of hints about interviews. Firstly, make sure that the camcorder can see both of the "victim's" eyes. Profiles tend to lack intimacy and give the impression that the subject is talking to someone way off on the sidelines. If the interviewee keeps turning away from the camera then get the reporter close (and I mean close) to the lens axis. The other annoyance is an interviewee who keeps looking at the camera. This is easily sorted by placing a "reporter light" on top of the camera lens such that it blinds the subject if he looks at it. Cruel, I know, but at least it stops them looking down the tube.

Wherever possible have the camera lens on the same level as the subject's eyes. Place the camera above their eye level and they tend to look weak and vulnerable, below their eye level implies arrogance and dominance. Some subjects have deep set eyes or heavy eyebrows which throw a shadow onto the eyeballs. Eyes which don't have any highlights or reflections look "dead" and need a bit of help to bring them to life. We've mentioned using an on-camera light to stop subjects looking at the lens, well this is also the cure for pothole eyes. Sometimes the talent will have greasy skin, sweat slightly or simply have the sort of complexion which bounces light like a bowling ball. There are two solutions, one involves small, barely noticeable adjustments to the lights. The other way is to buy a powder compact. A bit of powder on a sweaty brow saves ages messing around with lights and reflectors.

There's a broadcasting mantra which goes "Zoom during the question, not the answer"

light on", as you turn on the juice because it's guaranteed that phrase will get the talent looking straight at the unit and consequently blinded for the next five minutes! A good phrase is "Cover your eyes... light coming on".

SINGLE LIFE

For the majority of single camera interviews, a lighting set-up known as "standard portrait" or three-point lighting will provide more than satisfactory results. It's the basis of just about every lighting occasion and once you know how to set it, you can start adjusting and playing with it, expanding your possibilities, secure in the knowledge that if it all goes pear shaped you can quickly bung up a portrait rig without any problem.

If you've got a light meter then use it! Especially in studio or indoor situations where you've got to balance different sources. You might be able to see the features of someone sitting in front of a window and your viewfinder might even seem to show that it's within acceptable limits but beware. The viewfinder shows

ABOVE:
Two cameras are useful when the interviewer and interviewee are of different heights.

which is worthy of noting. Like all advice, it's not written in stone and a slow zoom in during a long answer can look really good, especially if the zoom creeps in with a barely perceptible movement. Don't overuse this effect though. Save it for a poignant answer. If it doesn't fit, then save it for another occasion.

TRICK AND TREAT

You can "trick" a single camera set up into a multi-camera shoot by recording the reporter's questions separately and then adding them in the editing. It's best to record these after the interview because (a) the reporter knows the questions he or she has actually asked; and (b) the interviewee is already on tape and can't prepare or rehearse answers.

At this stage the main errors to avoid are, the reporter looking in the same direction as the interviewee and the eyelines conflicting. If the subject is recorded looking towards frame left, then the questioner should look frame right (and vice versa). Be careful with this technique, it can very easily go wrong and look awful and obviously fake.

Occasionally you'll be asked to record an interview or meeting with more than one camera. This is the sort of challenge which videomakers should be searching high and low for. It's a great opportunity to put a team together and attempt a more complex job. Allow plenty of time to prepare the location and light the set. The same portrait lighting can be deployed on each subject and, with a bit of thought, some lights can be used for more than one purpose. If you're recording a discussion on a stage or hall with a public present, be aware that if you want shots of the public, you'll need to light them as well, without blinding them such that they can't see those taking part!

When directing a multi-camera interview try and get the cameras to vary their shots between close ups, mid shots and long shots with the emphasis on the close ups. Also try to make use

of the "over shoulder 2 shot" to show both the subjects in relationship to each other. If you are using more than two cameras, then it's a good policy to keep one camera just for the presenter so that you've always got a shot you can cut to.

Finally, when you are editing, follow your feelings rather than the rules. If the cut looks and feels wrong, it is wrong. Try to avoid cutting long shot to long shot and – whatever you do – maintain a sense of humour. Multi-camera jobs are all about teamwork and co-operation.

HOLIDAYS

Without doubt the most common use for a camcorder, aside from "home movies" (we're not being tasteless it's actually true) is to record a document of your annual holiday. Now there is one big problem associated with this, and we're sure almost everyone has experienced it. The daunting invite to just pop round and see a friend's holiday video has seen the demise of more than a few friendships! Sitting through a

BELOW:
Holidays are without doubt the most popular videos shot by camcorder owners.

TWO TRIBES

There are two distinct approaches to shooting a holiday video. One is a relaxed, carefree style, grabbing a few choice images but not taking your digital camcorder with you everywhere. The second is a full on, "this is a trip of a lifetime, not to be missed, pack everything" approach. And which one you pick depends on the trip you take.

You can, unquestionably, bring back a decent holiday record by just taking your camcorder and the odd accessory with you. On the other hand if you don't view videomaking as a chore, and see it as an integral part of your expedition, then you can choose to take a careful requisitioned amount of equipment.

Let's start with the first option. Before you travel group together all your equipment and then piece by piece discard the stuff you know in your heart of hearts you won't use. You should be left with a digital camcorder, a couple of tapes, a spare battery, a mains charger (with the appropriate adaptor for the country you're travelling to) and maybe a couple of filters. Two tapes, probably around two hours' worth,

ABOVE AND BELOW:
Make holiday videos more visually interesting by looking for some striking images.

couple of hours of badly shot, boring holiday video is more than any reasonable person should have to bear, and what's so frustrating is that it doesn't have to be this way.

The ideal holiday video should be a taster, illustrating the outstanding moments from what was a relaxing or invigorating trip. Every shot has to earn its right in your production and only then will you be able to invite the neighbours round.

LEFT:
Sand and salt water damage camcorders. Be protected from the elements.

should be more than enough raw material for any two-week vacation, because you're going to be shooting wisely. Filters aren't essential, so weigh up the practicalities of taking them. However, a plain skylight filter might be useful as it protects the lens from potential problems such as sand and grit.

So what you're leaving behind is a tripod, because you can use walls, posts, fences, anything as a form of stabilization, headphones – remember it's a holiday video not a film set, and believe us you don't want the unnecessary attention, lights and a microphone. You can do all that you need with the basics and some imagination.

BE CREATIVE

Unless something jaw-droppingly exciting is happening, never press the record button until you've thought of an idea. Ideas are the saviour for holiday videomakers – and the poor souls you inflict your video on – as they can transform a dull situation into a truly entertaining specta-

cle. As you travel to your destination try and note down some ideas of what you'd really like to capture, and when it's feasible to actually go and video it. A travel guide book is useful here, allowing you to pinpoint tourist attractions and the off-the-beaten-track locations you might want to capture.

Don't start filming as soon as you get to your location, instead spend time getting a feel for your destination. If there's any chance of revisiting the location before your return journey, then go back once you've worked out what to do. Friends and family can go and enjoy a relaxing coffee or unexpected shopping expedition, while you quickly nab the shots you've been pondering over for the last couple of days. They'll thank you more for that than for keeping them somewhere longer than necessary, while you dash around hoping you've got enough material.

Not everywhere you venture will have a laissez-faire attitude to filming so find out where and when you can film. For example the streets

of New York and Los Angeles might seem like a permanent film set but you might be asked by police to stop filming, purely because you don't have a permit. Strange, but true. It's not only foreign outdoor locations that could create filming problems, museums and galleries can have strict anti-video/photography policy, so be careful here as well.

SHORT AND SWEET

The most common videomaking mistake, especially on holiday videos, is the length of time each shot lasts. You don't have to stay on the same shot for several minutes to take everything in. The human eye processes information very quickly and your viewers want to be entertained, not bored. Keep shot lengths short, anything more than five or six seconds for a shot, when nobody is talking, is too long. Also be keen to embrace a variety of angles. Don't just put the

camcorder to your eye and press record, that way all your shots will invariably be at the same height. Try mixing low and high angle shots, as well as including a variety of long, medium and close up shots. And remember if you want to be closer to a subject, move closer to it, don't hit that zoom button during recording. You can use the zoom for close-ups, of course, just make sure you do it before you start recording. Ensure you also find the time to shoot some cutaways to use as fill between shots and sequences. When it comes to editing, cutaways can be an absolute godsend in covering up mistakes or shots that don't last as long as you want them to.

Travelling light also lets the videomaker make use of the beauty of digital camcorders – their size. Digital camcorders provide an opportunity for unobtrusive filming. You can take them along to most locations and shoot away without the public realizing what you're doing.

LIGHT AND SHADE

If you are on a sun-kissed holiday then there are a couple of situations you should take into consideration. Light is very different all over the world, but wherever you get harsh sunshine your camcorder is not going to like it. If you can move to manual exposure and stop down to reduce the amount of light entering the lens, otherwise you'll have a holiday video that looks more bleached than your hair. If you don't have manual exposure try and move to a program AE settings, such as sand and snow specifically designed for bright light, and if you don't have that, then try an AE setting which reduces the exposure to at least some degree. Natural light reflects and this in itself can cause a problem with lens glare, you don't want natural sunlight rebounding into the lens, as it can damage the camcorders lens and circuitry.

Images as beautiful as they might be require a decent soundtrack to complement them, so be sure to think about whether you want to add music or narration at a later date. If you do then you'll have to put the camcorder in its 12-bit PCM stereo mode, so you can audio dub at a later date. If you don't intend to add anything then put the camcorder in its 16-bit PCM stereo mode to ensure the sound you record is the best it can be.

And once you are back home again, please give some serious thought to editing your holiday video. Even if you have been judicious with the amount of footage you've shot, you will still have more than you need (or should have!). Spending some time separating the wheat from the chaff will make for a truly watchable video.

Finally remember to take a break from your camcorder... it's a holiday after all!

EXCESS BAGGAGE

Alright so much for the easy option what about the videomaker who wants everything. Well, you'll be pleased to know that although you'll be taking more equipment the advice is more to the point than option one!

The same rules on shot lengths, angles, permission, exposure, sound and editing still apply but the planning stage is a little more involved. If you have decided to make shooting a video a central theme of your holiday then you first need to decide what to take and you'll also need to decide how you will be transporting your valuable equipment. Along with your camcorder, you'll be stowing away a tripod, headphones, a microphone, maybe a light, extra lenses, filters – essentially all the stuff you've left behind in option one. With all this extra equipment you will need a durable and large

holdall or even a camcorder rucksack. There are many on the market, but you might be surprised at quite how expensive they are. Still, compared to the expense of your digital camcorder and all the accessories, the investment is worth it.

Planning is even more important if you're taking this seriously and you should look into gaining permission in advance if you're considering visiting any out of the way, or extreme places. A good tip for creating a fully-rounded holiday video is to capture footage of maps, trails, visitor passes and still photos of the places you've visited, and perhaps music that's indigenous to the region, so that you can incorporate them into your completed production.

Another thing to bear in mind, should you be travelling alone, is not to forget to put yourself in the video from time to time. It's often the case that a videomaker returns from a trip, exhibits their work, only for people to ask where were you then!

RIGHT:
Variety is the key to successful documentaries. Different shot sizes, cutaways, using maps, signs, and a multitude of settings all help to create an interesting atmosphere.

DOCUMENTARIES

There is a richness and diversity to shooting documentaries that can probably only be equalled by the creativity involved in shooting a fiction video. As far as documentaries go, the world is your oyster. You can pick any subject life has to offer and turn it into a short or long form video of note. Fortuitously documentary making offers the videomaker a chance to break away from the constriction of shooting a scripted fiction video, or the formulaic nature of weddings and interviews. This is possible because a lot of the time the videomaker has no control over what happens. Good documentaries come from good observation and a key to this is getting access to situations and making the subjects feel natural and relaxed, rather than trying to dictate what happens and when.

Shot lengths will be much longer in documentary making as you simply have to keep rolling and wait for "life" to happen. This means that editing is the key to success. You will undoubtedly shoot more footage in a short documentary than a short film or interview. It is once you have the footage that you will see how the documentary will develop, and for this reason it's worth being open minded about what direction the video takes. Because you have no pre-ordained shooting script, your initial theme might change, your central character might not be the most interesting aspect of your material in the end, and you might end up disproving any point you had intended to make.

RIGHT:
Consider your audio options. Will all your dialogue be written in advance and delivered to camera, or will you add narration later, or will you have a blend of voice-over and interviews.

RIGHT, TOP TO BOTTOM:
**Mix shot sizes, but
don't cross the line
in a sequence – as in
the second image here.**

ACCESS ALL AREAS

As well prepared as you might be for documentary shooting, it's likely that you will run with the bare essentials most of the time: a camcorder, basic microphone and lighting. Audiences don't expect intricate tracking shots or smooth Steadicam work in documentaries, they are increasingly media literate and understand context, and you can take comfort from the fact they won't expect *Lawrence of Arabia* standard cinematography!

The success of fly-on-the-wall and reality TV shows is that they get close to their subjects, warts'n'all, if you like. And digital video has played an enormous part in achieving this. Digital camcorders are small enough to be unobtrusive, and their image and sound quality is capable of rendering a sound recordist and lighting assistant surplus to requirements most of the time. Imagine this scenario: you are trailing the Managing Director of a small publishing affair as he is implementing potentially unpopular changes on his staff. He is far more likely to be candid with you as you interview him, or video him with staff members, if there is just one person with a digital camcorder. Re-jig the scenario and follow him with a team of three of four people and you'll no doubt see some impressive clamming up.

Again audiences don't expect gloriously lit scenes, or moody and intense situations courtesy of intrepid lighting design. They expect the odd grainy moment, the odd dark corridor, the odd incorrectly white balanced moment – context is everything, and if what you're showing them is entertaining or fascinating they'll follow you. The same goes for sound – just make sure you pick up what you need, nobody is expecting dynamic stereo switching and sound effects – just the juicy titbits of gossip!

WEDDINGS

Ding dong indeed! Weddings are fraught, intense, exhausting affairs, and not just for the bride and groom. Weddings are the most traumatic occasions for a videomaker, they do not offer you the chance of a re-shoot, you are at the mercy of the weather, the relevant authorities and all the arrangements that rise above "the video" as a priority on the big day. By relevant authorities, we are talking about the service itself, the venue and the conductor, be it a religious or a civil affair.

You can plan until you're blue in the face with weddings, but it's worth nothing, unless you are quick to react on the wedding day. And that is how you succeed at wedding videography – you act and react fast. Still, videoing weddings can be a worthy and fruitful occupation – more than a

few serious videomakers use it as a regular earner – and there is a lot of satisfaction in making what could be viewed as a boring situation into a visual spectacle that will bear replaying.

The first rule of Fight Club is … sorry, of wedding videos is give the client your best. It's their big day and an important moment for family and friends. Speak to the couple about what sort of video they'd like, and always remember to speak to the relevant authority about permission to video and whether any fee is payable to them. You should also check about copyright for music, as well as performing rights licenses for the choir and organists.

Research your location, think about where you want to place the camcorder. And then remember to ask the authority whether it's OK to place your equipment there. For lighting

ABOVE:
At weddings the temptation is to try and capture everything on video but try to avoid filming somebody who is also filming at the same time.

RIGHT AND BELOW:
Recce your location:
Check out the best and
least obstructive
locations for your
camera and mic, but
most important, get
permission to film.

factored in a long period for editing you might want the extra footage a second camcorder can provide. If possible try to rehearse the sound recording, as churches can boom and echo away. Try and get to a rehearsal, if there is one, and make sure you have a selection of microphones to choose

requirements discuss what's feasible – could the church increase the light, or dim it, can you bring any stand mounted lights in, etc. You might have to make do with available light, which could alter where you need to place the camcorder.

Decide whether you want this to be a one- or two-camera shoot, and if so, who will be your second camera operator. Most productions can get by with one camcorder, but if you've

from – even if you have to hire them. You might want to record ambient and background sounds on a separate audio only recorder, while using a directional mic, close to the couple and priest, to pick up the ceremony. A microphone designed to give a general sound recording, such as the one usually built into your DV camcorder, will leave you with variable sound quality.

It's up to the bride and groom how in-depth you go with the video, not everyone wants to be

videoed getting ready for the big day. But whatever you present the happy couple with at the end of the day, make sure it's edited tightly, and compresses some wonderful memories into a tidy, efficient watchable package that family and friends won't feel they have to endure rather than enjoy. Titles are a necessity for rounding out the package, and be tasteful with the music soundtrack, should you wish to include any.

A Woe Free Wedding

Your location list might go a little something like this:

- Research location
- Speak to relevant authorities and gain permissions where necessary
- Arrive early on wedding day!
- Footage of bride and groom getting ready
- Guests arriving at the venue
- Groom and best man awaiting fate!
- Outside the venue as bride arrives
- Bride enters venue, walks up aisle if in a church
- Ceremony
- Confetti, celebration, depart for reception
- Arrive Reception
- Speeches and Toasts
- Evening "Do"

6

Editing

Editing

BASIC EDITING

Aha! It is time to get serious. Having amassed all the footage and audio necessary to create your fiction, holiday, interview, documentary or wedding video, editing gives you the opportunity to manipulate it. In many respects this can be the most creative part of the videomaking process. Editing is really all about telling a story, and it is where you get to decide how you want to tell it. As with many aspects of videomaking there are no hard-and-fast rules, simply guidelines to help you along. Sure there are conventional approaches which will enable you to get an idea of what the "norm" is, but remember this is your video and, ultimately, it is whatever works for you.

You will undoubtedly find that you spend more time editing your video than you do filming it. But though this fact tends to put off many amateur videomakers, editing is an absolute necessity if you are to create fully real-ized productions. Not every shot you have taken will work, and sequences you thought worthless might reveal themselves to be the very pieces that make your video "tick".

THE VERY BASICS

At its very core, editing is choosing what to include and what to lose, and then splicing the remaining bits together. However, there are a myriad of permutations in how you reach a final cut. As you will discover later in this chapter, computer-based non-linear editing (NLE) systems are by far and away the most popular and versatile forms of editing in the 21st century. The arrival of digital video heralded a new dawn for editing, with powerful software and hardware packages available for decreasing amounts of cash. DV camcorders are particularly friendly with computers because of their digital signals and connections. Digital Video, with its improvements in picture and sound quality, also enables higher quality edited videos to be made.

BELOW:
Editing at its most basic is deciding what you what and what you don't want in your video.

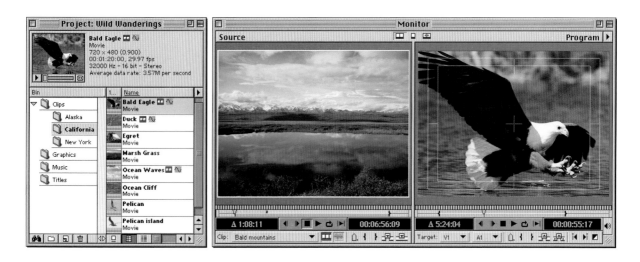

ABOVE:
It's possible to edit out "unnecessary" scenes and still have a sequence that works.

The reason – there is no loss in quality. If you transfer digital images and sound to a computer; the footage remains digital while on the computer, when you output back to DV tape or create DVDs or Video CDs, the transfer signal is still digital, and when played back on either of these formats the image is still of digital quality.

If you are still troubled by the prospect of editing, let us lay it bare for you. All video editing involves copying images and sound (dubbing) from a player (camcorder or VCR) to a recorder (DV camcorder with DV-in connection, computer or VCR). The player plays back the original camcorder footage in the sequence you

Shot	Tape	TC In	TC Out	Description	Take	Comments
1	3	00:00:14:02	00:00:24:06	WS fans outside venue	1	Pics and audio OK
2	3	00:00:36:20	00:00:53:14	WS fans inside venue	2	Good
3	3	00:02:12:00	00:04:40:04	MS interview: singer	5	Too Slow
4	3	00:05:25:12	00:38:50:24	WS band performing	1	OK
5	3	00:40:38:10	00:41:11:17	CU fan interview	2	Audio NG (no good)
6	3	00:41:20:13	00:44:19:21	CU fan interview	1	Good

select, while the recorder records it. Et voila, you have dubbed a tape.

The simplest way of doing this is to hook your camcorder up to a VCR, via Scart or AV cables, press play on the camcorder, and record on the VCR. Seeing as this is done in one fell swoop, without changing the order of the scenes or sequences, this is referred to as linear editing. Every scene is followed by the one you shot next, and there can be no swapping around of sequences. Non-linear editing allows you to move a shot or sequence from one part of the video and place it somewhere else – i.e. a dramatic moment taken at the mid-way point of your tape, can be moved to the end of the video to provide a fitting conclusion.

Below we have identified the more basic types of linear editing you can attempt without recourse to a computer. Though, it has to be said, to get the best out of digital video you

LEFT:
Audiodub on your camcorder allows you to add new dialogue or music.

really should consider computer-based packages.

IN-CAMERA EDITING

You simply shoot the footage you need in sequence, without the need for transitions or effects. Every shot you have is as long as you want and you do not want to add any extra audio. Complete your shooting list and dub it all straight to a recorder.

ASSEMBLE EDIT

This involves using the player to transfer the footage you want to a recorder, but you can decide what sequences to send and in which order. Using this system you can rearrange your video and use shortened clips.

Still feeling a bit muddled about where to start, well try this example out for size. In order to start editing you need to know what footage

you have. As laborious as it might sound, you should log every shot you have taken. Play your material back and write down each new scene. So you might write:

Scene One: Jamie in the garden playing football

Scene Two: Jamie kicks ball over fence and breaks his neighbours kitchen window;

Scene Three: Irate neighbour confronts Jamie about his conduct.

This system will allow you to build up a picture (on paper) of what footage you have. For a more detailed list, or **logging sheet** as it is often referred to, you can add timecode information which indicates the number of hours, minutes, seconds and frames each shot lasts. You can use this list to create what is known as a paper edit: simply an outline of your edited video written down. This can save hours in front of a monitor or VCR spooling back and forth through your footage as you desperately try to track down a shot. This system is often referred to as **off-line editing**.

Even at a basic level you ought to be thinking about adding sound to your edited footage. A short burst of music over a landscape shot can indicate a mood, while narration can often help to clarify a point not particularly well explained by your subject. It is all about widening the scope of a video to encompass as much information as possible, and to provide the viewer with a rounded product.

It is possible to add narration and music to an edited piece fairly easily. To ensure you can include additional soundtrack material you need to have set your camcorder to its 12-bit PCM audio mode – having a piece of footage recorded in 12-bit next to a sequence in 16-bit is going to cause you problems, as you simply will not be able to dub over it. Determine the length

of the section to which you want to add a new soundtrack and then write the narration or choose the music to fit this gap. Tickled by how it sounds and looks? Well, you are getting the editing bug.

Advanced Editing

For amateur productions, the basics of editing are likely to be enough to lead to the creation of a competent final cut. Yet, as we have mentioned, editing is about shaping your story, and once you feel confident enough with the building blocks, then it is worthwhile journeying onwards to more complex waters: where your bolder vision lurks, where your longer-form video hides and where you might find someone called a client, who wants to pay you for your work!

For a start, if your work is going to appear outside your living room, you need to record a few seconds intro of dead/black footage at the start of your master tape, or alternatively, you could record colour bars. This prevents your edited video from beginning with a jolt at the start of a tape – when the picture from VCRs can be unstable.

Insert Editing

More professional productions utilize a system called **insert editing** rather than assemble editing. To understand this concept you need to know what a control track is. Every digital camcorder creates a control track, pulses, one per frame, along the edge of a tape which helps the camcorder maintain a consistent speed. In assemble editing, the control track is transferred with the images and audio as one package; in insert editing it is not.

Insert editing involves recording new video

and audio over existing recorded material and you can only do this on a tape which has a control track already in place. Therefore, you will need to find the tape onto which your video will be dubbed and give it a control track. You do this by "blacking up a tape", essentially laying down recorded material for the tape's duration. Black is favoured to prevent any colour bleed from previous colours. You now have a continuous control track to lay your footage onto. When new footage is added, the existing control track and timecode recorded on the tape are left undisturbed. This reduces the chance of glitches in edits/cuts, such as visual disturbances.

Amateurs tend to make use of insert and assemble editing together, as they will "black" the copy-tape with their assembled footage, giving it a continuous control track, and then insert shots, such as cutaways, over them, erasing the original footage underneath.

ABOVE:
Think about how shots work next to each other, in terms of size, angle and lighting.

EDITING PRACTICES

If you are intending to edit in a conventional way then you will need to satisfy the viewers' expectations with regard to what they see. Conventional technique maintains that editing should not distract the viewer, i.e. you do not notice good editing. To achieve this it is necessary to ensure there is a consistency in the images the eye sees. Similar shots placed adjacent to each other are easy for the brain to assimilate, and for it to understand what is going on. Moving between different shot sizes requires a little time for the brain to process the new information. However, having too many

ABOVE
Editing is about telling your audience a story.
Make it interesting visually as well as in terms
of content. Avoid using the same type of shots,
it makes for blandness and slows the pace.

similar shots, from the same height and angle, will lead to a production which is lifeless and predictable. It is perfectly acceptable to make a significant change in shot size and angle when you are cutting on the same subject or when there is a major shift in the content of your video. For example, you can easily move from a wide angle shot of a man waiting for a bus to a close up of him exchanging money and ticket with the bus driver. If you had a medium shot of the man waiting, followed by another medium shot of the bus coming into view, and then a medium shot of the man boarding the bus, the overall effect would be very bland.

One part of editing that can confuse a novice is the comings and goings on the screen. By that we mean entrances and exits, not technically through doors (or windows), but into and out of the frame. Convention dictates that you cut when the subject has nearly left the frame, and in so doing you make sure the viewer does not have an empty frame to look at. The same is not always true of entrances, you can leave a frame empty before the entrance of your subject as it enables the viewer to figure out the location. You can then have your subject appear into shot, whether it is walking into a room or along a corridor.

As you become more comfortable with editing a sequence or video together, you will learn that you can add pace and tension to a video by altering its rhythm. Faster cuts naturally increase the pace, while adding an almost frenetic feeling. Shots left to run for longer provide a languid feel. You can further alter the pace of your video by adding a music soundtrack and cutting specifically to this. This is blindingly apparent in a music video promo, but think about action sequences in your favourite

NON-LINEAR EDITING

Having covered the basic types and conventions of editing, you are ready to think in more depth about non-linear editing. As mentioned above, this is the process of using a specialized computer editing program to trim and rearrange your shots. Not only does this method keep your footage in a digital form throughout the process, avoiding any loss of quality, it also allows you to edit non destructively – the footage you have shot on tape is captured to your computer. It is this captured footage you work with rather than the original footage on your tapes, meaning that no matter how much you hack and slash your way through a scene, you always have the original to fall back on should things go horribly wrong. Non-linear editing systems generally come in various configurations – software only, software and hardware bundles (usually in the form of a DV capture card for installing in a PC that does not have existing DV inputs) and real time capable software/hardware bundles. (Real time bundles feature additional processors on the capture card that augment your PC's existing processor so that complex video effects can be previewed instantly rather than waiting for your PC to render pixel by pixel the changes wrought upon your video by the use of a special effect.)

The process of non-linear editing is easily broken into three parts: capture, edit and output. Capture is the process of getting footage from your digital camcorder onto your computer's hard disk drive. When we talked about computers earlier we mentioned IEEE1394 cable, sometimes known as **Firewire** or **iLink**. This cable allows the huge volume of information contained in video to be transferred to your computer, but it has another trick up its

movies, car chases are a good example. The music will have been chosen for its compatibility with the images, but you might need to edit shots and sequences so they appear in time with the music. It is useful to understand music and its structure to use it compellingly, but this usually involves learning to count how many beats are in a bar of music. You can then make sure you cut on the beat, rather than off it.

RIGHT:
A storyboard interface
provides a simple
visual guide to the
construction of your film
but lacks complexity.

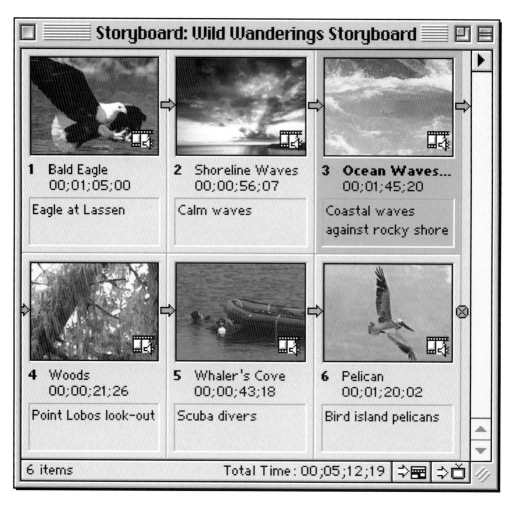

sleeve. Thanks to a standard known as **OHCI** (Open Host Controller Interface), many combinations of hardware and software fit into a predictable set of parameters that allow differing manufacturers to predict how their equipment will work with that of others. The upshot of this is that the software capture facility on your computer can communicate with your DV camcorder. This is known as device control, and it makes the process of capturing video to computer an easy task.

When you begin capturing you simply tell the computer what sort of digital device is attached to the 1394 cable (or let the software figure it out for itself) and tell it that you wish to capture from that device. Then, without having to press a single button on your camcorder, you can begin controlling the tape within it from the computer, moving it to the points it needs to be at.

Capture is usually carried out in one of two ways. You can play the tape from the start and hit a record control in the software interface to capture footage as it appears. This method is great for shorter productions, but for times when you wish to capture a large number of scenes from different spots on the tape, you may wish to use **batch capture** if it is available on your software. Batch capture is a method whereby you speedily shuttle through your tape logging in and out points for your footage. This

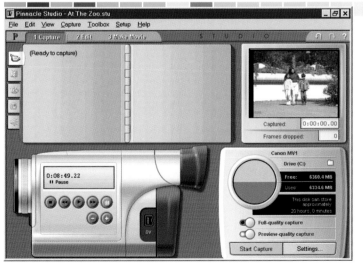

Timeline

Video 2
wild wanderings | Opening Title | wild wanderings | | Globe.psd

Video 1
Bald Eagle | Ocean Waves | Woods | Whaler
Channel Mixer | Transform | Basic 3D

Audio 1
Voiceover | Voiceover | Voiceover | voiceov

Audio 2
Eagle Calls | Ocean Waves | Whaler's Cove

Audio 3
Sound Track | Sound Track

10 Seconds

log is then used by the computer which, for example, knows that it has to capture from 00:32:21:20 through to 00:34:07:14 before fast forwarding and capturing 01:12:09:00 to 01:14:07:09. While it charges around your tapes grabbing what you have asked it to, you can wander off and have a cup of tea.

Captured footage is stored in **bins**, a term which relates to the old days of film editing where film was stored in sacks known as bins. Before capturing, you will have set up a project area with these bins within it. Your project area will define certain things depending on the complexity of your software. Chances are it will know that the Project has a name, is using DV

as its source material, at either 24 or 25 frames per second and in either PAL, NTSC or SECAM. The bins allocated within this project area will probably involve one overall bin that holds all the raw footage with other bins designated according to your organizational preferences. We would suggest a bin for trimmed footage, a bin for inserts and cutaway shots, a bin for audio tracks and a bin containing any title sequences or captions that will arise.

Having captured and arranged your footage, it is time to begin editing. The layout and operating method of different editing programs vary wildly, but at the very least you will have a window displaying your bin and its contents,

ABOVE:
You can manipulate the dialogue from one scene to be heard over another during the editing process.

another listing the effects and transitions you can apply, a monitor window for playing back clips, and either a timeline or a storyboard.

Timeline and storyboard editing are two different ways of keeping track of your projects, with storyboard being by far the simpler, but also the less versatile. In either case you are dragging video clips from your bin, adjusting their duration, adding effects and then placing them in your actual project. The timeline or storyboard is where you see the progression of your project as multiple clips joined together rather than just individual clips in your bin.

With storyboard editing you will see a sequence of single frames laid out sequentially from left to right across the screen. Each of these frames represents a different scene. When you have adjusted a scene you drag it to the point in the storyboard that you wish to place it and let it go. Gaps between the different pictures allow

you to place transitions, such as wipes or dissolves, between consecutive clips. Storyboard editing is as simple and intuitive as it gets, which is why it is the standard method on most of the sub-£100 entry level editing programs.

Timeline editing is more complex to start with, but once you have learned the basics, it actually allows for more complicated types of edit to be performed much more quickly than would be the case with storyboard editing. In timeline editing you have multiple tracks or channels for audio and video, arranged hierarchically. Many systems allow a staggering number of these tracks, but to keep things simple we will assume you have just five tracks. Video 1 and audio 1, video 2 and audio 2 and a transitions track between the two video tracks. Working on the basis that the uppermost track receives priority (if you have a minute of video on track one, parallel to a minute of video on

track two, the uppermost will play in the monitor window and the lower will not), it is easy to see the convenient creative possibilities offered by timeline editing.

For example, say you have two clips side by side on the same video channel, but the cut between them does not work, or is an unwanted jumpcut. You can easily cover the cut with an insert simply by trimming one of your cutaway shots to the right length and placing it on a higher video channel in a position that overlaps the cut between the end of one clip and the beginning of the next. As your video plays along the lower channel, it will play your existing footage until it encounters the cutaway on the higher channel, play through it and jump back down to the lower channel to carry on with the video beneath, bypassing the bad join via the insert shot.

This method is similarly applicable for inserting transitions on the transitions track. The ability to have the audio on a separate channel is also useful in a similar fashion. Say you wish to cut away from a scene involving a conversation in order to show the subject of that conversation, but wish to retain the audio so that the dialogue from the conversation scene can be heard over the cutaway. Simply manipulate the audio channels in the same way as you have manipulated the video, in this case by discarding the audio channel that goes with your cutaway and leaving the audio that goes with your scene in the uppermost channel.

The wealth of options, techniques and special effects available with most mid- to high-end NLE packages is huge, and worthy of a book in itself. Editing should be regarded as much a part of

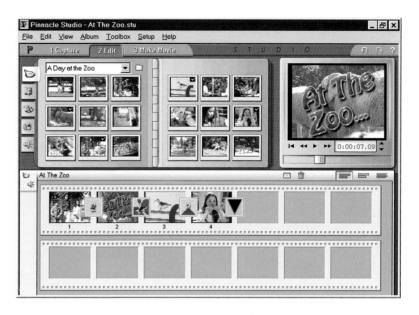

your storytelling skills as screenwriting or camera work. It will take a long time to master your NLE system, but it is a vital area not to be scrimped on – you are using digital video and should aim to take advantage of the masses of creative possibilities that this medium entails.

Output is the final stage of non-linear editing. You now have a completed film on your hard drive, but unless you wish to invite your audience to sit around your PC, then you have to get it back out into the real world. At this point you generally have three options: you can export as a computer video file (usually Quicktime, Realplayer or Windows Media); you can export the film to any incorporated DVD creation software you may have; or you can put it back out to tape. We will be looking at the computer media formats and DVD creation in seperate chapters, so for this section, we will simply concentrate on output back to tape. In this case the video goes back out the same way as it came in, via an IEEE1394 cable. As long as you have not made any major changes to the format of your work, this is usually a simple case

of rendering all your special effects and hitting a button marked export. Easy peasy.

Computer editing involves a large learning curve, but also one that you can work through at your own pace, easily creating simple edits long before you embark on getting to grips with the more flashy and complicated capabilities of your system. Additionally, editing is fun and will invariably open up a videomaker's eyes to the multitude of possibilities for presenting footage. Do not be surprised if your plan to simply trim a few shots to size and join them together is quickly swept aside by a tidal wave of creativity. It means that your project may take longer to complete than you had planned, but it also means it will be a better finished product and you will have had a lot of fun making it.

BURNING AMBITION – CREATING DVDs

Format wars are as much of a pain in the neck today as they were back in the early days of consumer VCRs. Back then you had a choice of VHS, Betamax or V2000, and the choice you made would eventually be responsible for much sniggering if, by the mid-80s, your friends came round for a visit and happened to see the diminutive shape of a Betamax cassette sitting next to the walnut-panelled bulk of your VCR. There was only ever going to be one winner in the videotape format war and oddly enough it was the one that was probably the least satisfying.

Fast forward to now and you have another format war developing, this time over DVDs. This whole book is about digital videomaking, so it would be remiss of us not to have a brief look at Digital Versatile Discs.

People are naturally sceptical of new formats. After the embarrassment of every Beta buyer of the 1980s, new forms for home visual entertainment such as laserdisc and CDTV were sure to be greeted sneeringly by those who had already had to change VCR at least once (or three times in the case of my family, who picked up first a Beta machine, then a VHS machine helpfully supplied by the traditional bloke in the

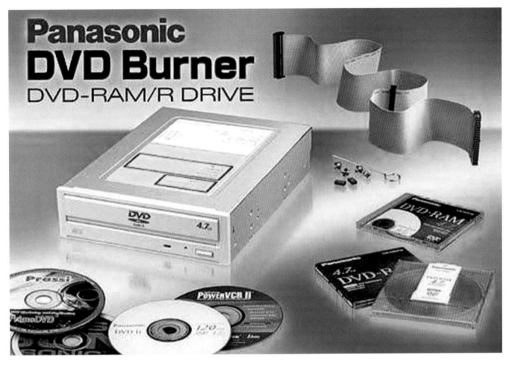

pub who failed to outline the differences between PAL and NTSC, before finally settling with a VHS deck which, wonder of wonders, actually worked with British TV). It is no great surprise that people who have to risk lashing their money on an obsolete format often adopt a wait-and-see approach to new technology.

Unlike laserdisc, however, DVD is not going to go away. It has got the backing of the major manufacturers and moviemakers and it delivers noticeable benefits. It can push even a bog-standard TV to its quality limits thanks to its ability to display 625 lines, as opposed to VHS which has approximately 240, the wealth of storage space that allows extras such as "making of" documentaries, commentary and even multiple camera angles to add value to a DVD movie, and the simple lack of quality degradation that comes from reading 0s and 1s with a laser as opposed to dragging metal speckled tape backward and forward over VCR heads.

Many people, especially movie buffs, dived into DVD early on simply for the quality and the extras, but others have chosen a more cautious stance, believing that DVD would not be a viable replacement for VHS until it was recordable.

Well, these days it is recordable, and even re-recordable, in much the same way that you have CD R and CD RW, so problem solved, right? Wrong. You now have a new format war between DVD RAM, DVD-R/RW and DVD+R/RW, and those little plusses or minuses can represent the difference between being able to transfer your digital video to a disc that all your friends can watch, or to a disc that can only be used as a very shiny drinks coaster.

The way in which a DVD Writer burns information to a disk essentially involves large volumes of information stored in grooves, smaller volumes stored in pits on the "land" between the grooves, and in some cases additional information stored on the land itself. Put simply, the way in which a DVD has information burnt affects the ability of a DVD player to read that information.

anyone else's player, you may be the sort of person that is willing to take that gamble and get in on the ground floor.

DVDs (and their little brother, VCDs, which, as their name suggests, use CD as a recording medium,) are essentially video signals, compressed to a manageable size and stored on a reflective disc that will be read by a laser beam.

The compression type is something you will have heard of – MPEG. MPEG2 in the case of DVD, and MPEG1 for VCD. MPEG stands for Motion Picture Experts Group and refers to a set of algorithms used by a computer or DVD player to work out what information has been removed or reduced in a signal to bring it down to a more manageable size. Using MPEG compression it is possible to store only the information that relates to vital frames of video whilst keeping track of only the changes, rather than the repeated information between one frame and another.

The process of creating DVDs is far too complex to go into here, but it is essentially three separate procedures – encoding a video file, authoring/designing a disc and burning the information. However, we can offer you a few hints on which method to choose when it comes to learning about, and finally implementing, the creation of your discs.

If you wish to create DVDs or VCDs, it is not enough simply to have an edited video project on your Hard Drive and a DVD writer installed. You need to create a video file in the MPEG format of choice (MPEG1 being of approximate quality to VHS, MPEG2 being of significantly better quality than VHS.) This can be done in two main ways, either through hardware (an encoder built into the chips of a card to be installed or attached as a peripheral to your computer) or the option we would recommend – through software.

This new format war is daunting, and unfortunately it is still way too early to predict which format will eventually win, but that is no reason not to consider joining the party. DVD writers are dropping in price, with the major models available for a reasonable price. The actual media too is becoming cheaper, having nearly halved in price. Every company that has anything to do with recordable DVD has a compatibility list somewhere, usually on their website, showing what hardware, and to a lesser extent, software, their products will work with, and while there is the risk that one day your DVDs will be unable to play in

The reason why we would recommend software encoding is simple: it is becoming the standard method. Many editing packages already have a utility included for the purpose, and separate, stand-alone DVD creation software is also available. Many CD burning programs already contain an option for creating VCDs, making it possible to put movies on to CD-R discs at a fraction of the cost of creating full-quality DVDs. In addition to this, the variables involved in creating MPEG files for disc are so numerous that software provides the perfect solution, allowing you to work slowly and carefully through dialogue boxes and "wizards" – step-by-step guides that, metaphorically, hold your hand throughout the process.

Buying a dedicated software package or using a utility also avoids the problem of having to use separate encoding, authoring and burning software (one to create the video file one to design the disc layout and information patterns and combine them with the video file, and one to actually burn all this information to disc). Most DVD creation software contains the encoding, authoring and burning programs in one package, simplifying the process and removing the possibility that your burner may not be able to handle the information rate you have chosen, or other such compatibility issues.

It is a complicated procedure, but you are getting in reasonably near the ground floor, and best of all you are keeping your digital video in the digital domain.

BELOW:
imovie is a simple, but effective NLE programme supplied by Apple. It can't burn DVDs but is capable of encoding your projects ready for burning.

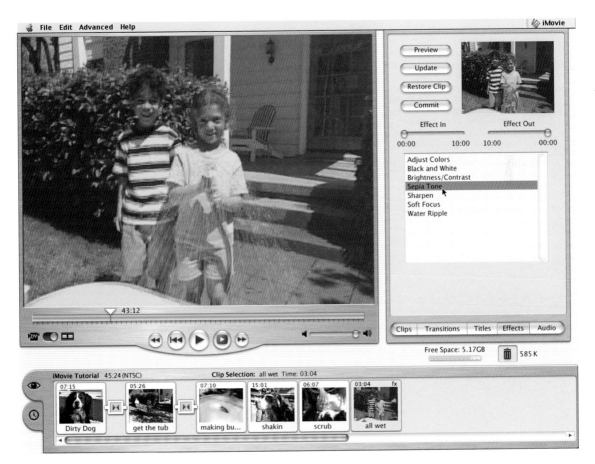

7

Distribution

Distribution

WHY STAY WITH DIGITAL?

There is a tendency for digital video-makers to feel obliged, at the final stage of their production, to move from video to film. Those videomakers with big screen ambitions are frustratingly told that they should transfer their completed master-piece to the glory of film, because that is the only way it can be viewed. They might also be told that it is the only way they are going to be taken seriously as a producer.

This is nonsense. Most amateur videomakers may only show their video from the comfort of their living room, while those with a bigger appetite have, as we will demonstrate later, a multitude of avenues to investigate. Camcorder clubs, festivals and Internet sites all have the ability to host video.

The beauty of digital video, as we must have said a hundred times in this book, is its quality. It puts the tools needed to make affordable pro-ductions that look good into the hands of amateurs and semi-professionals. If you shoot on DV, edit on a computer and output back to DV tape or DVD, then you have a complete digital signal, and will suffer very little loss in image and audio quality, if any at all. You also have a piece of work that can be viewed by plenty of people. Record onto CD or DVD and you have a video that a vast percentage of your possible audience can watch on a DVD player or computer. Record onto VHS tape, and though you will lose some picture and sound quality, you will still have a high performance product, capable of being distributed easily. Should your video find its way onto the Internet, then you have a potential audience of millions, along with a way of seeing other videomakers' work, and the opportunity to contact them and talk about videomaking and its attendant thrills and spills.

THE TRANSFER SYSTEM

Some DV feature films have been transferred to film, such as *The Last Broadcast* and *The Blair Witch Project*. However, transferring to film is prohibitively expensive (we are talking upwards of £10,000) for an amateur videomaker, and the above films only managed it when they were "picked up" by a production company, or studio, who were willing to pay for the transfer, and then promote the film. The need for a film transfer is to enable cinemas to show the film,

BELOW:
The Blair Witch Project **(1999) was a success story for Digital Video.**

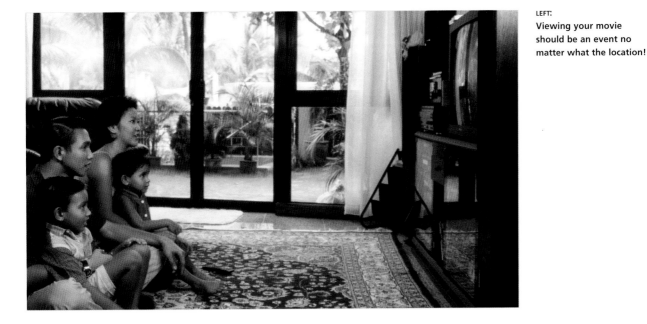

but at the risk of upsetting your outlandish ambitions of being the next Scorsese or Soderbergh, it is unlikely to happen. The number of videos picked up and invested in by production companies for cinema release is minuscule. It is far better to stick with your DV format and use the distribution and communications means at your disposal (and budget) to get your video seen. As you will see from a glance at the number of Internet sites listed at the back of this book, there is a wide variety that will allow you to submit your work. Some simply host a multitude of short films and videos, while others run competitions that you can enter. Bearing in mind that if you have edited with a PC or Mac then your digital video will already exist on your computer, then it should be a straightforward process of submitting your work.

GETTING YOUR WORK SCREENED

Shyness is a trait videomakers should banish from their personality. If you have made a video, you should want people to watch it and comment on it! It is very easy to sit in the comfort of your living room, and show your video to a select group of friends who will say "that's very good" or "that's nice". What you want is input from experienced videomakers who can tell you what worked in your video and what did not, plus, more importantly, why it did not work, and how you can put it right. Always remember that digital video is a visual art and it therefore involves an audience being able to see it, and naturally, wanting to comment on it. There is a dazzling array of videomaking festivals that you can submit your work to – and we have provided a list at the back of the book – but not everyone wants to start that way, preferring to build up their videomaking skills slowly before putting them under the microscope of competition.

THE CLUB EXPERIENCE

Joining a videomaking or camcorder club is a quick and easy way of meeting fellow videomakers. It is also a wonderful way of gleaning information about the subject. Camcorder clubs do have a "strange" reputation in the UK, as

they seem to be predominantly made up of the more "mature" videomaker.

Camcorder clubs, like any community or hobby group, are also a social outlet for people, and do not be surprised if you spend more time gassing over a cup of tea and a hobnob than making videos. However, amidst the fish and chip supper mentality of many clubs lurks an enthusiastic heart. Many of the club members you will meet will have years of experience in making their own films and videos, and yes, shooting on cine film is included in this. Learn as much as you can from them as they have valuable info to impart – usually from having found out the hard way.

Clubs tend to make productions together, as well as allowing members to work independently, and they are often involved in community projects, such as creating promotional videos for tourist authorities or training videos for local businesses. These are useful as they provide a means of getting involved without taking on the responsibility of making the whole video. It will give you experience of doing different jobs within the production crew and will allow you access to equipment you might not have at home. Though clubs tend to spend most of their time foraging for funds, many are now seeing the benefit of arts funding, gaining improved projection facilities and computers for editing, as well as new digital camcorders.

Another benefit of club membership involves the inter and intra club competitions you will be exposed to. As well as fighting it out against fellow club members with your production, you might also find your effort representing the club in a dogfight between two or three other clubs from the region, or in a national event. Experienced judges are used

to oversee these competitions and while they are honest and constructive, they are usually well practised in not damaging the sensitive disposition of amateur videomakers. This is a useful forum for getting feedback without harsh criticism so you can improve your video-making technique.

FESTIVALS

The short film is increasingly seen as a valid form of expression and audiences often realize that as much work has gone into a short film as a full-on feature. This is especially true, given the number of crew involved!

The UK has a very active festival circuit, catering for live action, documentary, animation and avant garde videos. Whatever form of digital video you create, there will be a festival out there for you to subscribe to. Naturally the selection process for these festivals is stricter than for camcorder clubs, and they can often have in- competition sections where you might end up actually competing alongside entries not just from Britain, but from Europe and also from the rest of the world.

There are also an incredible number of short film and video festivals the world over, and they usually take submissions (provided your video

ABOVE:
The adrenalin rush from seeing your work screened makes the effort worthwhile.

KinoFilm 2001

20TH - 28TH OCTOBER

SHORTS: THE FINAL FRONTIER

6TH MANCHESTER INTERNATIONAL SHORT FILM & VIDEO FESTIVAL

400
short films

60
screenings

9
days

infoline (0161) 288 2494

INTERNATIONAL PANORAMA
BRITISH NEW WAVE
KINO CHAOS: NEW UNDERGROUND CINEMA
BLUEFIRE - BLACK AND ASIAN FILM FOCUS
QUEER CINEMA
NEW DIGITAL MEDIA
EDUCATION PROGRAMMES
INDUSTRY EVENTS

VENUES

thefilmworks

cornerhouse

green room

www.kinofilm.org.uk

meets the theme) from whoever wants to submit their work.

MEET THE CRITERIA

Every festival has different procedures for accepting entries. Read their entrance criteria carefully, there are usually so many entries for these festivals that you do not want to give anyone an excuse to file yours in the bin! Check which format the festival wants to receive its videos in: this can be VHS or Mini DV, or it could be Video CD or DVD. Remember what the festival organizers need to see is a whole package. You might think your video is absolutely fantastic, but you want to make sure the judges feel the same way. To do this they have to see the video, and if it is in a blank case with no details or publicity blurb then they might not get that enthusiastic. You have probably spent an immense amount of time and effort on making your video; do not fall short by not promoting it properly. Make sure your video catches people's eye. Try and fashion a cover for it and if possible include information about the story/subject, cast and crew on there as well. It is fairly straightforward to create titles for your video when you are using a non-linear editing package and if you have a printer with your computer then you could even print out a still from your video as a cover image.

OPPOSITE AND ABOVE: Most countries have a thriving short film and video festival circuit.

darklight 4²⁰⁰²

call for entries 2002
join the bulletin
darklight archive
Straylight art exhibition
about darklight
contact us

Call for entries 2002

News 13/2/02 Darklight Digital film Festival 2002 call for entries

Darklight encourages the creation of contemporary film and art works that demonstrate and explore the creative potential of digital technologies. Darklight provides a unique platform for both newcomers and established artists and filmmakers from many diverse backgrounds to exhibit their work.

The ENTRY FORM, CONDITIONS and INSTRUCTIONS are now available on the site click here. The DEADLINE FOR SUBMISSIONS is MONDAY 15th APRIL 2002

Download
Call for enteries poster

straylight
exhibition

PRESS THE FLESH

If you can, try and get along to the festival. Most of the bigger events have opening and closing shows, as well as talks, seminars and workshops during the event. This is useful, as it allows you to meet the organizers, along with fellow videomakers.

If you are seen around you can promote your video, and as a result you get a bigger audience for your screening. Having made this breakthrough and are seen as an interested videomaker there is no end to the contacts you can make.

Even if you do not have a video entered into a festival, they are great events to attend. You get the chance to see what your competitors are up to, and to check out the latest, cutting-edge techniques. As has already been mentioned, there are also workshops and seminars at many festivals. Even if you cannot get enrolled during the festival, the organizers often have training courses running all year

round that keen filmmakers can join. Raindance, perhaps the UK's biggest independent film and video festival, is a good case in point. It runs courses all year round covering the basics and the advanced techniques of film and video production, from scriptwriting and storyboarding, to the different DV formats, lighting and computer-based editing.

It is also worth keeping an eye out for what camcorder manufacturers are up to. JVC sponsors its own videomaking competition in Japan (Tokyo Video Festival), but entrants come from all over the world. Amateurs from the UK have a strong record in the event, and though the general quality is very high, you are not always competing with videos that cost thousands of pounds.

Sony has been keen to promote the work of young videomakers, and in the past has run day-long seminars with pop promo directors and videomakers who use digital technology in their TV shows.

COPYRIGHT

Although it constitutes a book in its own right – a legal one – all videomakers keen to broadcast their own work should be aware of the issue of copyright. In the confines of your living room, you are usually safe to replay video and audio work without any fear of prosecution, but once you start looking towards an audience, there are rules you must be prepared to observe. These include using images from other films (such as a clip or still from a famous movie) and using copyrighted music (such as that from professionally produced CDs or DVDs).

Copyright can be a bit of a minefield, but here are a few of the basics. Any UK venue which exhibits your video – whether it is a community centre, village hall, exhibition centre, cinema or arena (ho ho!) – should already have a connection to, or licence with, the Performing Rights Society (PRS).

This means the venue pays a fee for the right to play music, whether that be the radio or a CD, and the PRS then sees that its members (songwriters, performers, producers, etc) get a percentage for the broadcast of the piece. You do not need to concern yourself with this,

BELOW:
Royalty-free music is an affordable solution to copyright issues.

unless the venue does not have PRS connections. It will then be up to you to contact the PRS (address at the back of the book) and cement a deal with them.

THE COST OF COPYRIGHT

What should concern you is that virtually all film and video festivals require you to clear copyright on your entries. This can simply mean writing to the copyright holder: film company, estate, music or publishing company and asking for permission to use the music, photo or video clip in your production. They can simply write back – and say yes or no! If they say yes, then there are a further two options. If the use of the copyright material is fleeting or negligible, then organizations will say yes, and usually not charge a fee. However, they can say yes and then charge a fee, in order for you to get clearance. Film and TV companies invariably have a member of staff whose sole job it is to gain copyright clearance for music and film clips. Fees are usually very high in this area, as the audience can run to millions, and a few seconds of a familiar tune (even if it is in the background) can cost a production company thousands of pounds. Companies and the estates who look after writers' and performers' rights, tend to be less harsh with amateur videomakers, though it is worth noting that the higher up the production scale your video goes, the more you will end up being charged!

As regards your own work, you need to know that there is no copyright on ideas, so you can only howl with frustration if someone comes up with a similar video to yours. That is unless you can prove that they have stolen the idea from you in the first place! However, the good news is that you own the copyright of any original footage you shoot – unless you specifi-

cally assign that to someone else. This can be the case if you are shooting a video for a client and they express a desire to hold the copyright, or they include it in the contract you sign.

In any case, we would advise you to contact a recognized videomaking organization – such as the Institute of Amateur Cinematographers (IAC) – which can help you resolve any copyright issues. These organizations have often arranged their own deals for members with the PRS, MCPS (Mechanical Copyright Protection Society), PPL (Phonographic Performance Limited) or BPI (British Phonographic Industry).

COPYRIGHT

• You cannot copyright ideas.

• You own the copyright to the material you shoot, unless otherwise agreed.

• Any other material you use will be covered by copyright (music, CD covers, photos, paintings, statues, books – written material, book covers, advertisements and packaging).

• Film and video festivals invariably require copyright clearance.

• Videomaking organizations have arrangements in place to help with copyright issues.

• Consider copyright- or royalty-free music. You pay a small fee and are entitled to then use the music in your video. It is also possible to purchase copyright/royalty free video which is useful for creating backgrounds and titles. A list of companies offering copyright – and royalty – free material is included at the back of this book.

OPENING NIGHT – ONLINE

The Internet is fast becoming the place to premiere your film, with innumerable sites providing hosting services for films that fit in with their audience demographic.

The whole point of the Internet is that there is something for everyone out there. From the pensioner wishing to find MP3 files of Billie Holiday songs to the sweaty-palmed businessman planning his trip to Thailand, every taste, no matter how mundane or how bizarre, can be catered for on the Internet, and that adds to the potential audience for your film.

Go to any search engine and type in "Internet Films" and you will be presented with an incredible range of sites specializing in providing online movies for people to watch. Some specialize in animation, others in social satire, or comedy, or video activism or … ahem … slightly more stimulating content.

Most, in fact, divide themselves into several sections and subsections in order to provide a niche for every genre of film. There are so many film sites now that many search engines, Yahoo!, for example, now have a specific directory for them, and as the broadband buzz continues to build, more and more people will have high-speed access to online films.

Of course, the potential audience for your film may not be enough for you to overcome certain reservations you may have for putting your film online. Maybe you are thinking of an Oscar nomination – which is a shame, because films that make their debut on the Internet are not eligible for those little gold statues. Maybe you are concerned that compressing your film down to a few megabytes will do irreparable damage to its quality, maybe you just cannot be bothered to go through the process of encoding your film into a Quicktime movie or Realplayer

ABOVE:
Thanks to the internet, your video can reach a global audience.

ABOVE:
Every genre of film is catered for online.

file. If you do not want to put your film online, there is no reason why you should, and if your film is not suitable for web viewing (lots of camera movement, special effects, fast editing, etc, will suffer badly during compression) then there may be no point in doing it.

But maybe your film is just right for the medium, and maybe the idea of having it watched by people from locations as diverse as Kinshasa and Caracas really floats your boat. In that case, what do you need to do?

Well, it is remarkably simple. Once again, the advantages of digital video make themselves known. The chances are that your NLE system already has what it takes to create an online movie, all you have to decide is how you are going to put it to use.

The simple option is to allow a specialist filmsite to host your DV movie. This usually entails little more than sending them a DV cassette with the film on it, which they will encode and post for you. If you wish to place the film on your own site, or send it to out to multiple sites already encoded (to save on posting dozens of DV tapes), then you have to decide on a few other things first.

DOWNLOAD OR STREAMING

The difference between downloading and streaming is simple. A progressive download film is a one big file that the audience can transfer from the host site to their PC in much the same way as software upgrades are transferred. You hit the download button and wait until the entire file has been transferred to your machine before playing back.

Media players, such as Quicktime, tend to look similar, but have very different capabilities.

The advantages of this method is that once you have the file you can play it back from beginning to end in one go and don't run the risk that elements of the file have been lost in transit.

The disadvantages are simple – if you are on a 56K modem attached to an ordinary phone line, then – in all likelihood – your computer can probably only receive around about 48 Kilobytes per second (even if your modem claims to be able to receive 56kbps, there is a limit to what your telephone line can actually deliver). Considering that most Internet films run into several megabytes at least, there is every possibility that you will be old and grey by the time

the whole file has downloaded (not to mention the risk that someone will pick up the phone and try to call dial-a-pizza halfway through the download).

Streaming a film, on the other hand, allows you to begin watching a film as it downloads. As long as it does not download slower than it plays back (given a well-specced computer and a broadband, or good dial-up connection, you should be OK) you will be able to sit through the whole thing as it plays, discarding what you have already watched to make room for the incoming stuff that is yet to make it to the screen.

The advantage of this method is that you can begin watching the film significantly quicker, having only to wait until a reasonable amount has downloaded before beginning playback.

The disadvantage is that you are cutting out the chunk of your audience who are not suffi-ciently well-specced enough to receive streamed video and taking the risk that frames of video will arrive out of sequence, or not at all, result-ing in a playback that is even more distorted and jerky than compressed video normally is.

To choose which method you will use, watch several streamed and downloaded movies to get a feel for the issues of time and quality. Keep in mind that you do not have to stick to one method either, many sites offer the same film as download or a stream, in a choice of Quicktime or Real Player. If you have the time and inclina-tion to encode your film in a variety of formats then you can offer this variety as well.

Having decided whether to make your film available as a stream or as a download you should think about the type of player you want it to be compatible with. Once again, you are not limited to choosing one and leaving the rest,

you can make your film available on as many players as you like.

COMPARING COMPUTER VIDEO PLAYERS

The big three video players are **Quicktime**, **RealPlayer** and **Windows Media Player**.

• **Quicktime** was the first of the media players to surface and often suffers from the fact that it originated from Apple computers. As has been mentioned earlier, Apple Macintosh computers have only a tiny share of the market compared to Windows-based PCs, and despite the fact that Quicktime is available for both operating systems, it has suffered due to the clannish nature of many computer users to the

point where Apple are rumoured to have considered making Quicktime a separate company in an attempt to get past anti-Apple bias. It is a shame that Quicktime has suffered this way, as it has the least jittery, glitchy playback of the big three and features a simple and intuitive interface.

• **RealPlayer** is an offshoot of an audio player and its best feature is the ease and quality with which it handles streamed video, which has made it the most common format, in our experience, for streaming video. On the downside, the interface is a mess and it does have a strange habit of occasionally making your web browser behave oddly.

LEFT:
RealPlayer is another of the most popular browsers.

• Finally the **Windows Media Player**, which is the mixed bag of the bunch. On the positive side it can, under the right circumstances, produce the best image quality of the big three. On the downside, it is ugly and non-intuitive. There is nothing you can do about the lack of user friendliness, but it does come with a selection of "skins" that allow you to choose its particular style of ugliness.

CODECS

All these players use **codecs** (COmpress/ DECompress) for compressing and decompressing video. Compression is the key to Internet movies, and images on computer, in general. MPEG, which we have mentioned in several places throughout this book, is a form of compression, and the same goes for JPEG photographs.

Put simply, compression is a system of ignoring certain less important elements of an image in order to save space and then reconstituting that image based on the knowledge of what information has been left out. The codec is the method by which this compression is achieved, usually in the form of assumptions based on the changes between frames.

To explain this further, if frame one shows a blue vase and frame five shows a blue vase, and frames two three and four all show a blue vase, why not ask the computer just to remember that there are five identical frames rather than remembering five separate frames all showing the same thing.

Having decided which type of player your video will be aimed at, you have a couple of options. Most of these players are available as free downloads, but as players only. If you wish to use them to create content, you will need to pay out for them and download the more advanced versions from the manufacturers websites or install them from disks.

We do not recommend this option, or the option of downloading a codec – such as Sorenson – and figuring it out for yourself. What we recommend is this – use whatever output capabilities your NLE system has. Even the cheapest entry level systems have some form of web output tool built in that you can use, and many feature an excellent program called Terran Media Cleaner (which can also be bought separately).

Why do we recommend using the utilities to hand? Simply because you have already learned how to be a videomaker – believe us, you do not want the extra task of learning to be a webmaster, AV content producer and server technician as well.

Most of these tools will offer you a range of options and will hold your hand as you work through them, from codec, to colour depth to optimizing for any number of bandwidths from 33K modem to ADSL. Terran Media Cleaner, for example, offers access to the different codecs used by the different players, so there is no chance of you deciding to use the MPEG4 codec from Windows Media only to find that the version of Quicktime you downloaded (without a licence) from your mate Freddy does not provide this. Using a tool for creating media for players is better than using players to create media for players. You do not ask Michael Schumacher to build his Ferrari.

It is this simple: try to do it on your own and you are in for a long, slow and disheartening learning curve. Use what is built into your existing software and you will be emailing the URL for your movie within a few hours.

Don't take our word for it....

"Just as cinema of the 20th century was created on celluloid, so will the cinema of the 21st be defined by the digital image. DV represents the ultimate democracy in storytelling: you can shoot cheap, edit cheap and create gold. It will encourage a thousand people to make films – some good, some bad, but they will be made. The future is already here. What are you waiting for?"

Tom Bainton,

Writer/Director/DV Producer, *Cool Hill Films*.

"There is something very intimate about video. It makes working in a direct, personal way easier to do. The portable nature of camcorders means footage can be taken secretly and quietly, its less inhibiting. You can capture moments of reality rather than having to contrive the content."

Carolyn Black, Artist.

"The reason I use digital video equipment is very simple – when we are out there, we see things people could live a lifetime and never see. To be there without the kind of camera equipment that can record it would be heartbreaking. It is not a very hospitable environment and it is very salt laden, yet we have never had any problems with our equipment. We are thrilled with it."

Colin Speedie,

Head of The Wildlife Trust's *Basking Shark Project*.

"The dramatic latitude the cameras afford is awesome. For example, there is one shot where I was able to stand on a chair and hold the camera up against the ceiling, framing with the LCD screen, to get a full length shot of a bath. The result was a shot not possible with either 16 or 35mm, unless you are on a set and can move the ceiling. With DV we were able to work hard, shoot fast and not worry about stock."

Dominick Reyntiens,

Director of *Inside Outside Lydia's Head*.

"The cost of actually shooting in 35mm is instantly prohibitive. With DV you can see what you have got straight away, it is cheap for what it is and it is of a quality that is broadcastable."

Cashall Horgan,

Animator/Director of *Paddy*.

"*Kingdom* has 175 CG shots in it – if we had tried to do that on film we would have racked up a serious budget. Shooting on DV meant we could afford to play around with different ideas, and if an actor needed to do ten takes the cost was insignificant. The flexibility that DV gave was brilliant. Technology has become a great enabler."

Kenneth Barker,

Writer/Producer/Director of *Kingdom*.

GLOSSARY

A

ACADEMY: In this instance, the older format of film stock with an approximately square aspect ratio, later superseded by stocks with wider aspect ratios, such as 2.35:1 or 1.85:1.

ALGORITHM: A standardized set of rules or procedures for repeated calculations, in this case, for compressing and decompressing video with as little quality loss as possible.

ANAMORPHIC LENS: A lens similar to a wide angle lens except it only enhances the width not the height creating a widescreen aspect ratio.

ARC: Aspect Ratio Convert, the process of taking 4:3 footage and converting it to a wider 16:9 ratio, sort of a reverse pan-and-scan.

ASPECT RATIO: The width to height ratio of the screen.

ASSEMBLE EDITING: Editing whereby material is joined on the end of existing footage, without any changes at the edit point.

AUDIO DUB: The recording, or re-recording, of an audio track on a video, which leaves the existing audio untouched.

B

BACKLIGHT: Light coming from behind the camcorder which highlights the subject's outline.

BROADBAND: Information delivery over a wide range of frequencies allowing for a very high information capacity. In this case used to refer to a permanently connected high capacity internet service as opposed to slower "Dial Up" services using ordinary domestic phonelines.

C

CAPTURE CARD: A device that adds DV sockets to computers not already equipped with them, often subscribing to the OHCI (Open Host Controller Interface) standard.

CARDIOID MIC: Partly directional microphone with a heart-shaped response field.

CAST: The actors in your film.

CCD: Charge Coupled Device, the image sensor that receives light from your camcorder lens and converts it into a video signal by assigning different values of electrical charge to represent the information contained by each pixel.

CHROMINANCE: The video signal which defines colour.

CODEC: A software or hardware item that applies algorithms to **CO**mpress and **DEC**ompress your video signal.

COMPRESSION: The process of taking the huge amount of information contained in a video signal and compressing it to allow smaller and more easily transferred files.

CONTINUITY: The method by which consistency and accuracy of costume, action, dialogue, etc, are maintained in film and video productions.

CRASH: When your computer gives up the ghost in the middle of a task, displaying the notorious "Blue Screen Of Death" and resetting itself – usually sending your current projects to digital heaven in the process.

CREW: The people who carry out tasks behind the camera – camera operators, gaffers, grips, etc.

CUTAWAY: Shot used as a break or link between principal shots in a film or video.

D

DEPTH OF FIELD: The range of object distances from a camera within which objects will be reproduced with sharpness and clarity.

DISSOLVE: Transition between two scenes where the first gradually disappears to be replaced by the latter.

DOWNLOAD: The act of importing a file from a remote computer to your own.

DVD: Digital Versatile Disc (sometimes referred to as Digital Video Disc) a disc similar to a CD that stores video information in MPEG2 format. Capable of higher quality then VHS video tapes.

E

EXPOSURE: Exposure of the CCD to the correct amount of light, which is controlled by the aperture and shutter speed.

F

FILTER: Glass, gel or plastic disc which fits over the lens to create special optical effects.

FIREWIRE: (aka IEEE-1394 or i.LINK) A high-capacity method of transferring digital video to other devices – such as a computer – and allowing those other devices to control the playback device.

FRAMING: The act of composing your shot and placing the elements of your composition in their required positions within the "frame" of viewable screen area.

FREEZE: When your computer locks and refuses to respond to inputs from the mouse, keyboard or other devices.

G

GAFFER TAPE: Vital stuff – holds cables to the floor, repairs broken objects, marks actors positions on the floor, etc.

H

HARD DISK DRIVE: The "long term memory" of your computer where software and projects are stored.

HARDWARE: The actual "physical" components of your computer-processor, monitor, etc.

HUNTING: Slow response from the camcorder's auto focus system as it takes time to bring a frame into focus.

I

IEEE-1394: (aka i.Link or Firewire) A data transfer protocol for moving audio and video footage, which also offers device control over VCRs and camcorders.

J

JPEG: A photograph converted into a computer file according to the standards of the Joint Photographic Experts Group.

JUMP CUT: An edit in which the perspective or framing or subject position between the two shots changes noticeably causing items on screen to appear to jump out of position, creating a jump in continuity. Sometime used as a stylish dramatic device, more often just a stupid mistake.

L

LINE, THE: In composition, an imaginary line drawn between parallel objects – if you begin shooting on one side of the line then move to the opposite side the two objects will appear to have swapped position.

LUMINANCE: The video signal which defines brightness (measured in lumens).

M

MASTER SHOT: Complete shot of a scene made in a single take in order to provide full coverage, usually used as a safety or backup should anything go wrong with other shots. Master shots are not always practically obtainable, but if you can get one its a good idea to.

MEDIA PLAYER: A program for playing back media files – such as video or music – on a computer. The major ones are Quicktime, Real Player and Windows Media Player.

MPEG: Motion (sometimes Moving) Picture Experts Group, a standard for compressing moving images into smaller file sizes.

O

OPERATING SYSTEM: The interface between yourself and various bits of computer hardware. Prominent operating systems include the various versions of Windows, Mac OS, Linux and Unix.

OHCI: Open Host Controller Interface, an agreement that allows various manufacturers to standardize their equipment for compatibility.

OMNIDIRECTIONAL MIC: A microphone that is equally sensitive in all directions.

P

PAN-AND-SCAN: The process of transferring a wider cinema image to a narrower television screen by panning around the frame and scanning the important elements, discarding the rest.

PIXEL: The smallest element of a picture- **PI**cture **EL**ement.

PROCESSOR: The brain of your computer that essentially reduces tasks and problems into millions of "yes", "no", "and" "or" questions.

R

RAM: Random Access Memory, the "short term memory" of your computer which stores things that are currently in use and passes information to the processor.

S

SHOOTING RATIO: The ratio between footage recorded and footage required. A shooting ratio of 3:1 would imply that three minutes of video are shot for every one minute that makes the screen. Used by Producers and Directors as a rough guide for planning how much tape is required, used by accountants to bemoan the amount of money spent.

SHOTGUN MIC: Highly directional microphone which can be aimed at its sound source.

SLIDE ADAPTOR: A device used for transferring still images from slides to video.

SOFTWARE: The programs used on a computer.

STEPPING RING: A device with screw threads of different diameter on either side, used when the threads on the lens barrel don't match those on the device you intend to screw into the lens barrel.

STREAMING: A method that allows a file to be played back as it downloads.

T

TELECINE: The process of transferring video to film stock, available in a variety of methods, of various quality at various prices.

TIMECODE: Coding system for audio and video for synchronization and editing. The timecode shows hours, minutes, seconds and frames, eg 01:12:58:02.

U

URL: Universal Resource Locator, otherwise known as a web address, such as http://www.digitalvideo.com/.

UNIDIRECTIONAL MIC: Microphone that is sensitive in one direction only.

V

VIGNETTING: The loss of picture area that happens when using an Anamorphic Lens at its widest setting.

VCD: DVD's little brother, which uses MPEG1 compression on a CD; similar quality to VHS.

W

WIZARD: A software tool that takes you through a complicated process in a step-by-step fashion.

Contacts

Camcorders

Canon (UK)
0800 616417
www.canon.co.uk
worldwide: www.canon.com

Hitachi
08457 581455
www.hitachitv.com

JVC
020 8208 7654
www.jvc.co.uk
worldwide: www.jvc.com

Panasonic
08705 357357
www.panasonic.co.uk
worldwide: www.panasonic.com

Samsung
020 8391 0168
www.samsungelectronics.co.uk
worldwide: www.samsung.com

Sharp
0800 262958
www.sharp.co.uk
worldwide:
http://sharp-world.com

Sony (UK)
08705 111999
www.sony.co.uk
worldwide: www.sony.com

Thomson
01732 520920
www.thomson-europe.com

Videomaking Organizations

Institute of Videographers
020 8502 3817
www.iov.co.uk

Institute of Amateur Cinematographers
01372 739672
www.theiac.org.uk

New Producers, Alliance
020 7580 2480
www.newproducer.co.uk

The Guild of Professional Videographers
02476 272548
www.professional-videographers.co.uk

Useful Websites

Online Films And Animation
www.alwaysi.com
www.thebitscreen.com
www.atomfilms.com
www.ifilm.com
www.level13.net

Magazines
www.camuser.co.uk
www.computervideo.net
www.whatcamcorder.net

Information and Resources
www.bfi.org.uk
www.cyberfilmschool.com
www.filmfour.com
www.filmmaker.com
www.plugincinema.com
www.projector.demon.co.uk
www.raindance.co.uk
www.shootingpeople.org
www.simplydv.com
www.stuntmania.tv
www.whorepresents.com
www.widescreen.org

Scripts
www.howtowritescripts.com
www.scriptservices.com
www.shootingpeople.org
www.wordplayer.com

INDEX

Accessories 30–35, 109
Action sequences 95, 99
Amputations 62
Anamorphic lens 50
Apple Mac 26, 27, 151
Aspect ratio convert 49, 50
Assemble edit 121
Auto focus 39
Automatic setting 38
AV cables 120

Bainton, Tom 153
Barker, Kenneth 153
Batch capture 128
Batteries 35
Bins 129
Black bars 48, 49, 50
Black, Carolyn 153
Blacking up a tape 123
BPI 146

Camcorder 12, 13
 bag/case 35, 45
 cost 19
 covers 31
 operator 87, 88
 rucksack 109
 Canon 14, 24, 45
Capture card 27
Car chases 99, 127
Cast 95, 96
Checklists 88
Cinematographer 72
Citizen Kane 54
Clapperboard 86, 87, 90
Clubs 138, 139, 140, 141
Codecs 152
Colour correcting filter 32
Colour temperature 73, 75
Colours 62
Compatibility 132, 134
Competitions 140, 141
Composition 54–5, 63
Continuity 66, 86, 87
Control track 122, 123
Copyright 113, 145–6,
Costumes 95
Cranes 35
Crews 85, 95, 96
Crossing the line 59, 60
Cutaways 66, 106, 131, 132

Deakins, Roger 72
Delegation 88
Digital effects 43, 49–50
Digital still snapshot 44
DIMM 29
Director 85, 87, 98
Dissolves 130, 132
Documentaries 111–2
Dollies 35
Downloading 149–50
Dubbing 119, 121
DV cable 26
DVD 13, 20, 21, 132, 133
DVD writers 133, 134
DV-in socket 119
DV-in-and-out socket 21, 22,
 24, 26
DV-out socket 21, 22, 24, 26
DZ-MV100 model 16, 21

Editing 65, 103, 114
Effects 14
Entrances/Exits 125

F stops 40
Fades 130, 132
Fees 146
Festivals 138, 139, 141–4
Fiction 94
Film transfer 138
Filters 32, 81
Firewire 17, 21, 26, 27, 127
Fish-eye lens 32
Focus ring 40
Framing subjects 58, 59

Gaffer tape 89
Gain 38
Grain 38

Headphone jack 24
Headphones 34
Hitachi 16, 18, 20, 21
Holiday videos 94, 103–9
Horgan, Cashall 153
Hunting 39

IAC 146
Idiot boards 96
IEEE-1394 17, 26, 127, 131
iLink 26, 127
Image chips 49

Image stabilization 23, 42
In-camera editing 121
Insert editing 122–3
Insurance 46
Internet 45, 147–52
Interviews 100

Jumpcut 131
JVC 12, 14, 16, 18, 44

Lens converters 32–3
Letterbox effect 47
Light 108
Light meter 101
Lighting 33, 39, 72–81, 95,
 113–4
Lighting technician 85–6, 87
Linear editing 120
Location shoot 88–9, 95, 113
Logging sheet 121
Lumens 75, 76
Luminaires 76
Lux 75, 76

Mac OS 26, 27
Maintenance 45
Manual controls 22–23, 39–40
MCPS 146
MICROMV format 15, 16, 18,
 20, 21
Microphones 17, 34, 114
Mini Digital Video 16, 18, 20
Miniaturization 25
Modem 149, 152
Motivation for cut 66
Movements 61–2
MPEG compression 16, 134, 152
MP-EG1A compression 16
MPEG2 compression 15, 16,
 21, 134
Music 145

Narration 121, 122
Neutral density filter 32
Night shooting 44
Non-linear editing 17, 22, 51,
 118, 120, 127–32

Off-line editing 121
OHCI 128
Output 131

Palmcorder 16
Pan-and-scan 46–7, 48
Panasonic 14, 16, 21, 44, 45
PCM stereo sound 17, 108
Performing Rights Society 113,
 145, 146
Permission 88, 109
Perspective 56
Pixellation 14, 23
Pixels 44
Point and shoot 38
Points of view 56, 71
Polarizing filter 32
PPL 146
Processors 27, 28
Producer 85, 87
Production assistant 86–7, 88
Profile 70
Program AE modes 41, 108
Progressive scan 45
Promotion 143, 144
Props 95
Pull focus 39

Quicktime 131, 147, 150, 151

RAM 28, 29
Real time 99
RealPlayer 131, 147, 150, 151
Recording 42, 97–9
Redheads 33
Rehearsals 91, 96, 114
Research 113
Reyntiens, Dominick 153
RS232 connection 44
Rushes 98–9

Safety 99
Scart cables 120
Screen ratios 47, 48, 49, 50
Screening 139
Script 90, 96
Shade 108
Shooting ratio 89
Shot lists 90, 97
Shot size 123, 125
Shot types 66–71
Shutter speed 40, 41
Skylight filter 32, 105
Skyscrapers 56, 58,
Sockets 24
Software encoding 134–5

Sony 12, 13, 15, 16, 17, 18, 20, 21, 32, 44, 144
Sound 17
recording 114
recordist 85, 87
Soundtrack 108, 115, 121, 122, 125, 127
Speedie, Colin 153
Splicing 118
Steadicam 31
Stills storage 25
Storage 14
Storyboard 65, 90, 130

Streaming 149, 150
Studio shoots 89
Stunts 95, 99

Tapes 34
Terran Media Cleaner 152
Thirds, rule of 55, 56, 61, 62
Thumbwheels 40, 42
Timecodes 42
Timelines 17, 130
Tokyo Video Festival 144
Toll, John 72
Tracking 61

Tracks 35, 130
Training courses 144
Transitions 131
Tripod 30, 31

Underwater housing 31
USB connection 44

VCR 119, 120
Viewfinder 24–5
Vignetting 50–51
Visuals 65

Wedding videos 113–5
Weights 62
Welles, Orson 54
White balance 40, 41
Widescreen 46–51
Widgets 22
Windows 26, 27
Windows Media 131, 151, 152
Wipes 130, 132

Zoom 14, 23, 32, 42, 50, 101–2, 106

Picture Credits

Original Illustrations by Geoff Fowler

The publishers would like to thank the following sources for their kind permission to reproduce the pictures in this book:

Adobe® 118b, 121, 125, 126-7, 128, 129t, 135, 150.
Advertising Archive 48, 12b
Courtesy of Philip Andrews 37.
Courtesy of Apple 25, 26, 27, 149b, 149m, 149t, 151.
AtomShockwave 148 "© 2002 AtomShockwave Corp. and its licensors.All Rights Reserved. 'AtomFilms' and the Logo are trademarks of AtomShockwave Corp. and may be registered in one or more countries. Other trademarks are owned by AtomShockwave or its licensors."
Courtesy of Adrian Bentley 40b, 62, 63, 104t, 105.
Birmingham Film and TV Festival 136.
Buzz Pictures 41b.
Canopus® 29.
Carlton Picture Library

38t, 45b, 68/9, 74tl, 75, 78/9, 84, 119, 124.
Cokin 32b.
Corbis 44/ Theo Allofs 41tl, Craig Aurness 73t, Bettmann 60b, 65, 98t, Anna Clopet 114b, Pablo Corral 59, CRD Photo 107, Richard Cummins 64t, Dennis Degnan 130, Duomo 41tr, Paul Edmondson 55, Randy Faris 38m, Mitchell Gerber 99, Kevin T.Gilbert 87, Rod Goldman 42, Philip Gould 67bl, 67br, Mark Hanauer 61, Walter Hodges 52, 58, Manuela Hofer 57, Jack Hollingsworth 139, Jeremy Horner 11, Lyn Hughes 115b, Dewitt Jones 67tl, 67tr, Ken Kaminesky 81b, Ed Kashi 36, Lawrence Manning 39, Darren Modricker 80, Marc Muench 98br, Charles O'Rear 104b, Joaquin Palting 38b, Caroline Penn 113, Picture Press 103, Paul Russell 106, Phil Schermeister 147, Paul A.Souders 108t, Chase Swift 64b, Ron Watts 5, 33t, 53, 56.
Darklight Digital Video Festival, Dublin 144.
Dell 28.
Edinburgh International Film Festival 143.

R. Follis Associates 32b.
Getty Images/ Paul Avis 114t, 115, Cherie Steinberg Coté 4, 92-93, Antony Edwards 89t, Ghislain & Marie David de Lossy 20t, Patti McConville 89-2[nd]from top.
Ronald Grant Archive 72br, 72t, 86b, 91, 31t, 47t, 95.
Hitachi Home Electronics Ltd 14, 21l, 22, 24t, 43, 49.
JVC UK Ltd 11, 12, 35tl, 45t.
Courtesy of Kobal Collection/ DreamWorks/Universal 35b, Twenty Century Fox 70, 71b, 71t, Cruise/Wagner 72bl, Artisan Pictures 93, 96, 137, 138b,Warner Brothers 98bl, Universal 141.
Manchester International Short Film and Video Festival 142.
The Moviestore Collection 47b, 54, 60t.
Courtesy of Kevin Nixon 4(2nd t), 8, 13tl, 13tm, 13tr, 20b, 30, 31b, 33bl, 33m, 33r, 34tl, 34tr, 35tm, 35tr, 37, 50, 51, 54t, 73b, 76, 77t, 77b, 90, 137, 138t, 145.
Stephen O'Kelly 74bl, 74b, 74tr, 81t.
Panasonic Consumer

Electronics UK Ltd 15, 18t, 23b, 23tr, 24b, 40t, 133, 134t.
Pinnacle Systems 117, 129b, 131.
Popperfoto 101.
Rex Features Ltd/ Timepix 86t.
Sharp Electronics Ltd 46b, 46t, 118t.
SONY 2, 4t, 13b, 16, 18b, 21r, 23tl, 34b, 83.
Topham Picture Point 89t, 3rd, 102./Chapman 6,140, Photonews 89b.
Vancover Film School 84, 85, 88, 97, 116, 122, 134b.
We're So Happy Films (Steve Thomas) 100, 108b, 110, 111, 112.
Courtesy of Vega Herrera Family 3, 4b, 9, 10, 19, 94, 109, 120, 123b, 123t, 154.

Every effort has been made to acknowledge correctly and contact the source and/or copyright holder of each picture, and Carlton Books Limited apologises for any unintentional errors or omissions which will be corrected in future editions of this book.